PAST JOYS

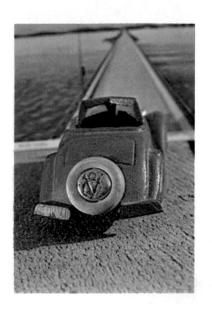

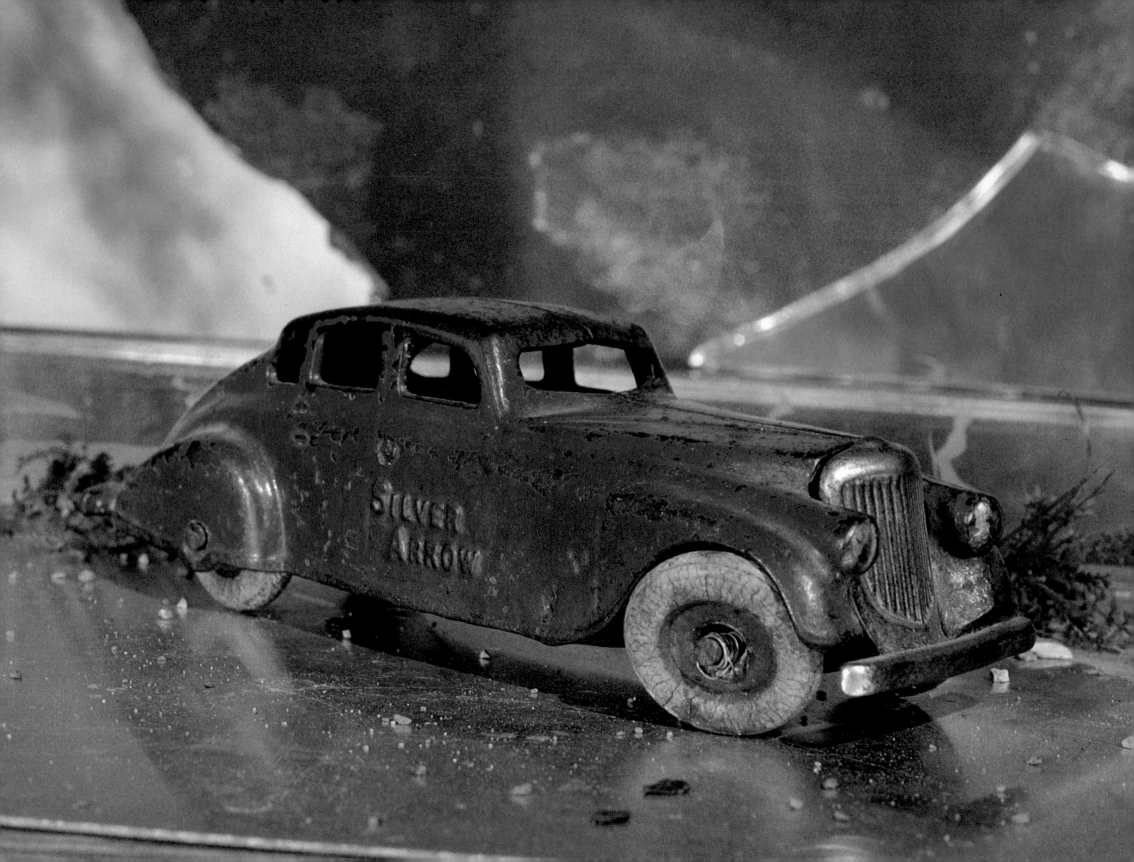

PAST JOYS

Ken Botto

Prism Editions

Chronicle Books

San Francisco

Published in association with Robert Briggs

For Janie Hesterly

I wish to express my gratitude and respect to Richard Schuettge, Jane Vandenburgh and Bob Harriman for their invaluable assistance and close cooperation. And special thanks to these friends for their help and support during the two-and-a-half years of the making of this book:

Ken Knutson	Bill Johnson
Zandra Knutson	Larry Kearney
Susan Sanders	Louis Patler
Sal Salmoria	Robert Bellucci
Leland Johnston	Jon Goodchild
Cathryn Johnston	Robert Briggs
Joanne Kyger	Long Linda
Ebbe and Angela Borregaard	Hess Terley
Tom Sehloff	

and all the collecting fanatics of the world.

Copyright ©1978 by Ken Botto.
All rights reserved.
Printed in the United States of America.

Back cover photo by Barry A. Schneier.

Library of Congress Cataloging in Publication Data.
Botto, Ken.
 Past Joys
 A Prism edition.
 1. Toys—Pictorial works. 2. Toys—Collectors
and collecting. I. Title.
TS2301.T7B65 779′.9′688720924 78-7999
ISBN 0-87701-116-8 slip-cased edition
ISBN 0-87701-115-X paperbound

Prism Editions
Chronicle Books
870 Market Street
San Francisco, CA 94102

CONFESSIONS OF A FANATICAL TOY COLLECTOR

It was in an old vacant, fake-brick-covered two-story house in a remote town in west-central Illinois. The house was located one block from the townsquare where the county courthouse sat. The town was surrounded by miles of cornfields and hog farms. From that house's basement —crammed with junk and trash—rose the musty odor of mildewed boxes and one yellowed, moth-eaten, stuffed Donald Duck. It was there that I found the treasures, for in the bottom of one of these moldy boxes, were three identical 1930s tin trucks—in battered condition, with dents, rust spots, missing parts, and broken black wooden wheels. All had once been repainted bright red—probably the handiwork of some long-ago kid. *They must have had the hell played out of them*, I thought, and as I remembered some toys I'd had as a boy, some deep and strong feelings were rekindled.

I was a Californian transplanted to the Midwest to teach in a university art department. America had just landed on the moon; Buck Rogers was coming true. But I was in that basement digging like an archeologist—discovering the remnants of America's past. I began to see more than nostalgic value in those toys, and the ones that followed them. I began to see them as sculptural art, a brand-new beauty, something to excite the eye and delight the soul.

The combinations of color were often bright and contrasting, were sometimes subtle. The cartooney shapes and forms seemed to be the genesis of much of contemporary art. They reflected the full-sized world but they also had an affinity with the absurd, the fantastic, the surreal. The toys had a sense of movement and history—for me, they recaptured the past better than the actual objects they imitated.

Toy collecting is progressive—addictive. I was overtaken by the mania. I became obsessed: a toy junkie, always on some crazy search for the next toy fix. The greatest excitement was in the search—running to flea markets, yard sales, tag sales—checking out every antique shop and junk store—lingering long hours at auctions only to see the toy go for an impossible price—tracking down tips that might lead to a great find, sometimes, maybe. . . . And now there's no end to it: the expeditions go on, into attics, basements, garages and other darkened hiding places where the forgotten old toys might be cast-off and waiting for me, the grown-up kid.

Ken Botto
March, 1978

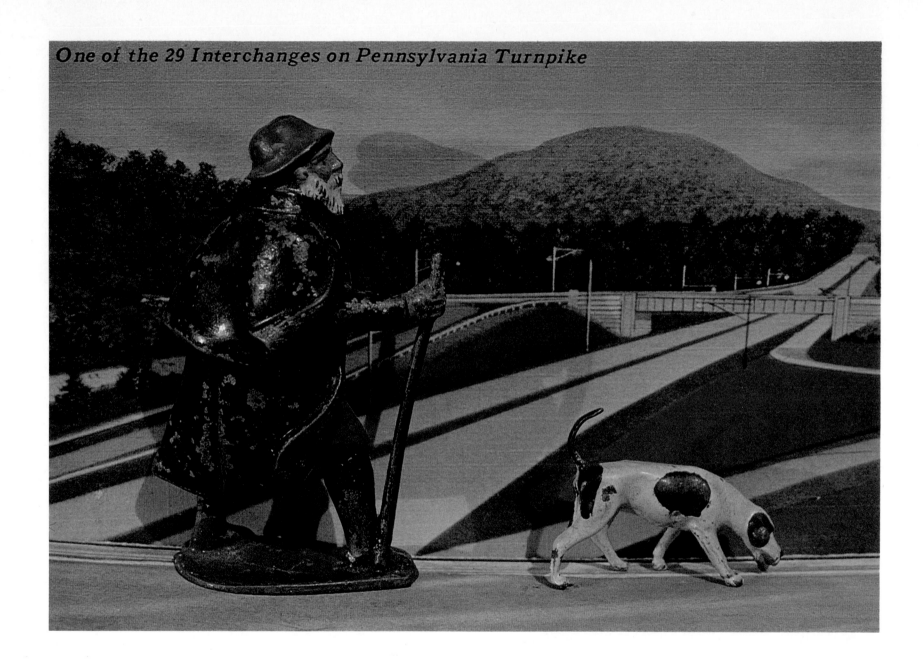

One of the 29 Interchanges on Pennsylvania Turnpike

This slush-cast character awakes from a Rip Van Winkle sleep to find the countryside changed. He and his faithful dog Bo wander over gray ribbons of concrete—searching for the land of their pot-metal past.

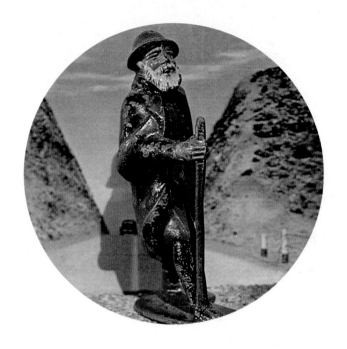

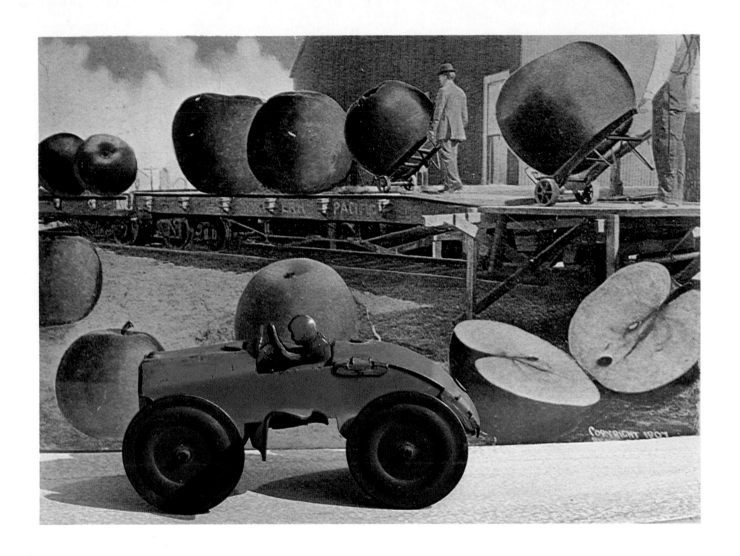

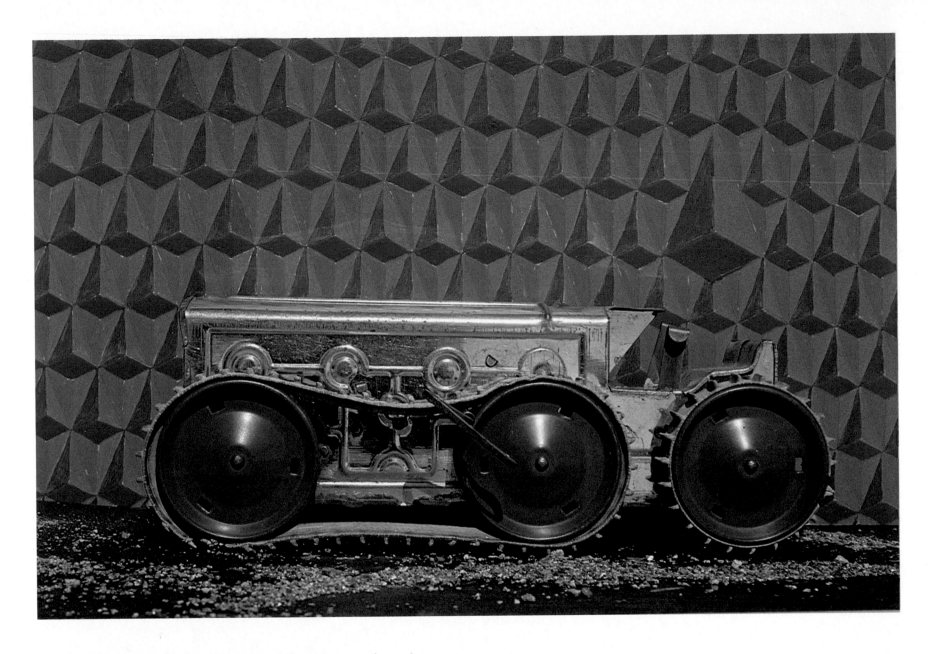

Down on the farm summer crops are ready to harvest.
This tractor—a shiny powerful Caterpiller—
waits on its tomato wheels to plow up the Lower Forty.

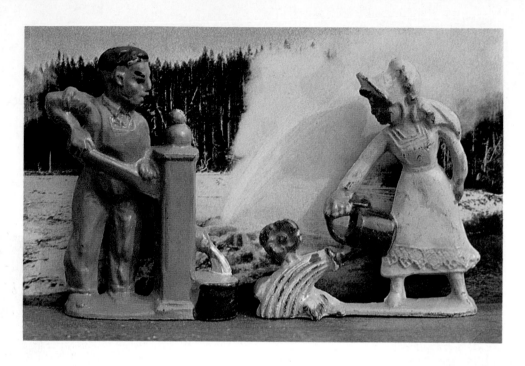

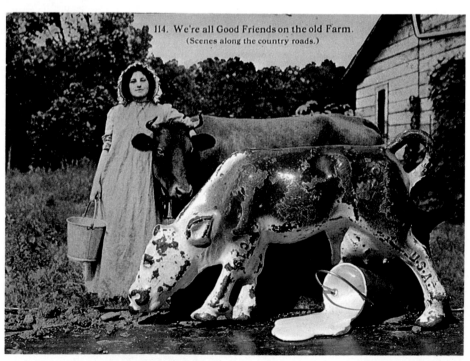

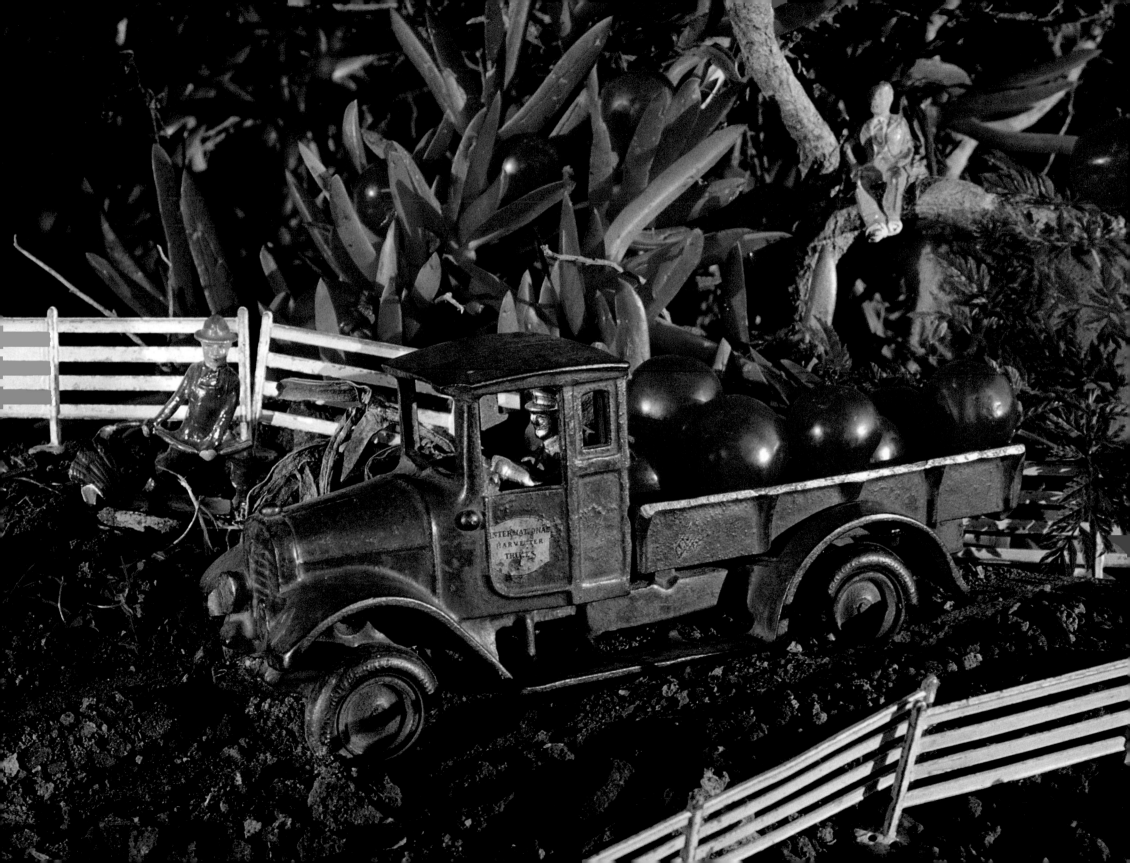

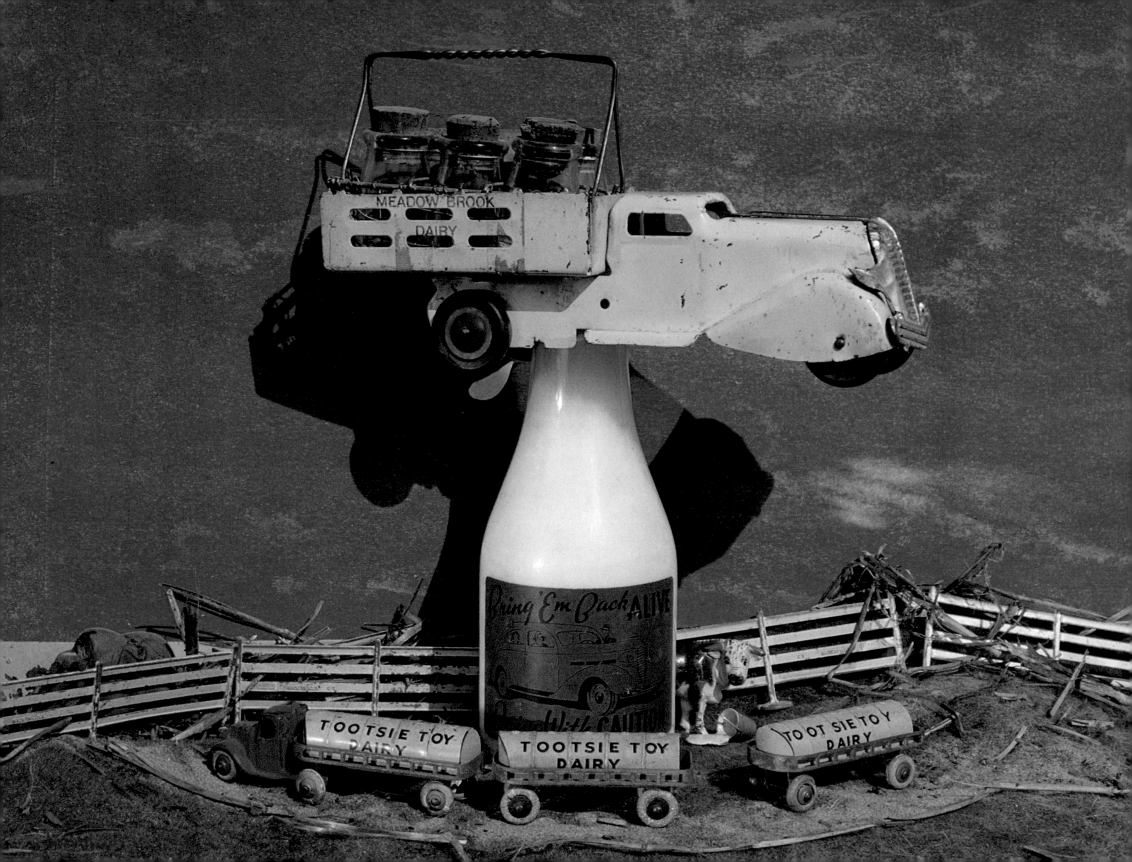

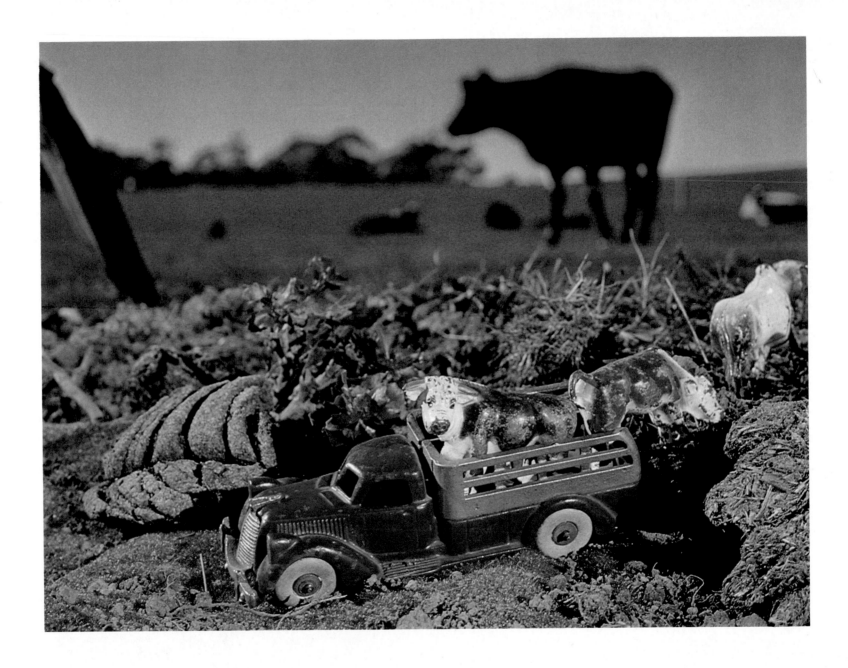

Farmer Brown's red nickel-plated Diamond-T stake truck
lugs through cow country rounding up his cast-metal cows—
not knowing that his barn-bound cargo has other ideas.

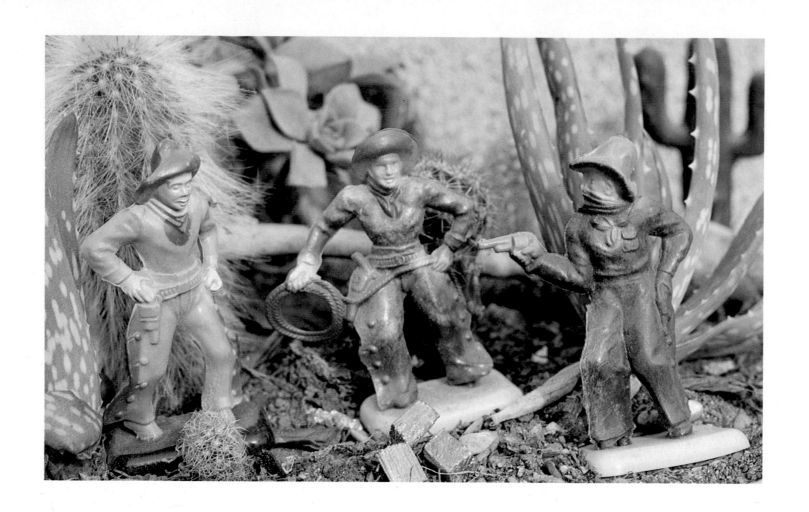

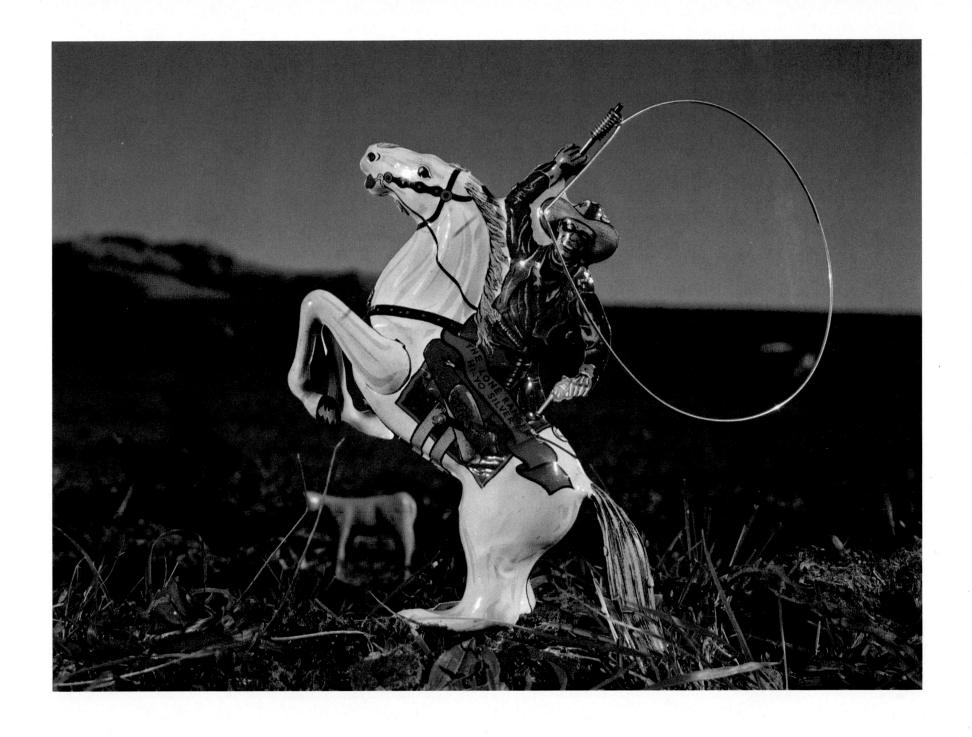

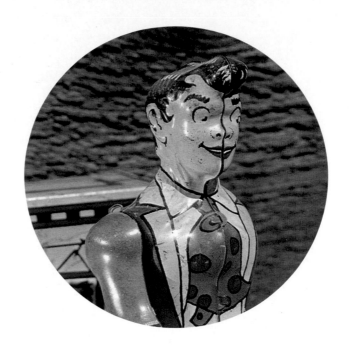

The Dogpatch 4 Hillybilly Band
springs to life with a rat^{ta}tat, rat^{ta}tat.
Lil Abner stomps out a dance to
Pappy Yokum's tinny drum beat—
Daisy Mae tinkles away at the keyboard
and Mammy Yokum, baton in hand,
lends a little *razzmatazz* to a wedding
near the Big Barnsmell Skonk Works.

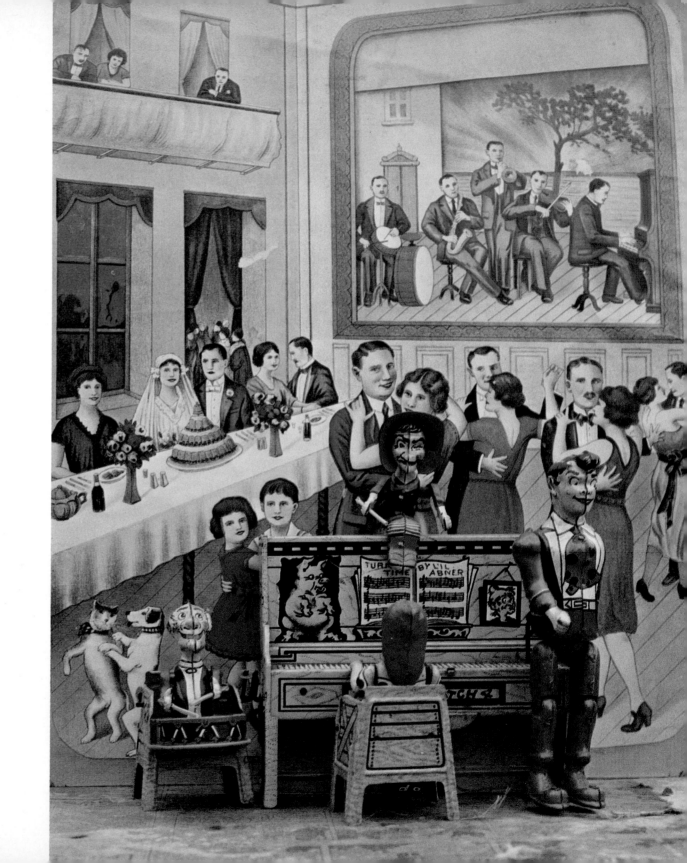

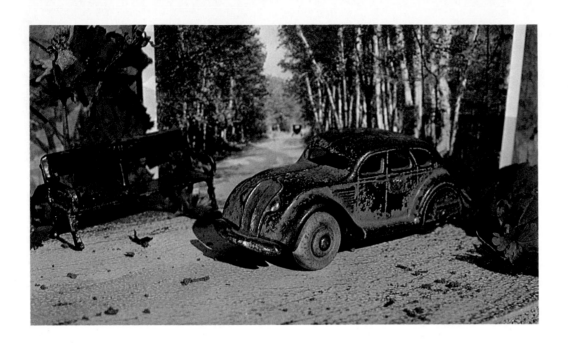

Passing park benches, birches and elms,
it's autumn time and this little Arcade Airflow
looks like it's going through the change of seasons, too—
shedding its light green paint while
its cast-iron turns to rust.

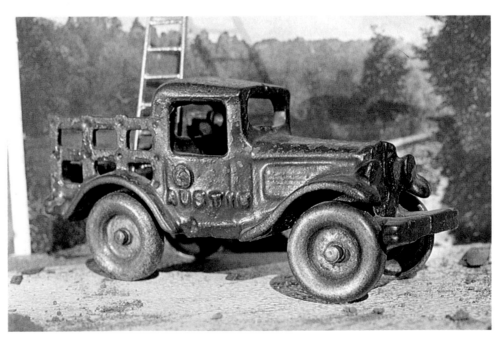

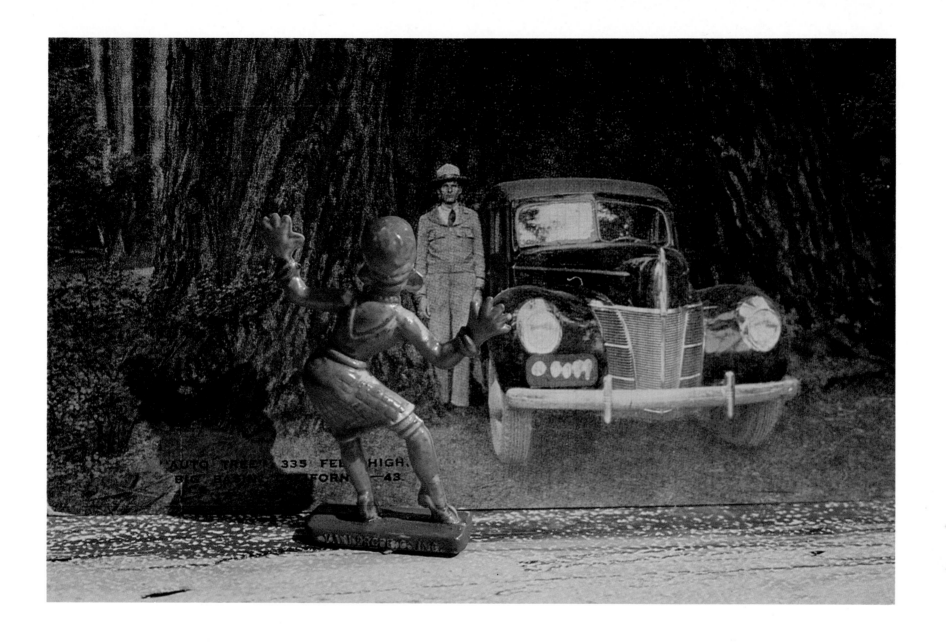

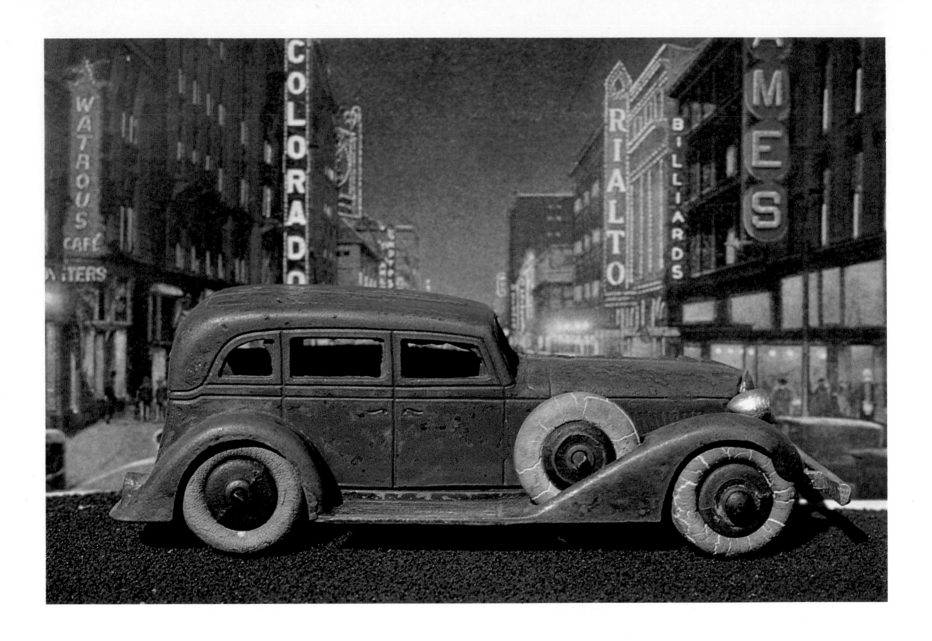

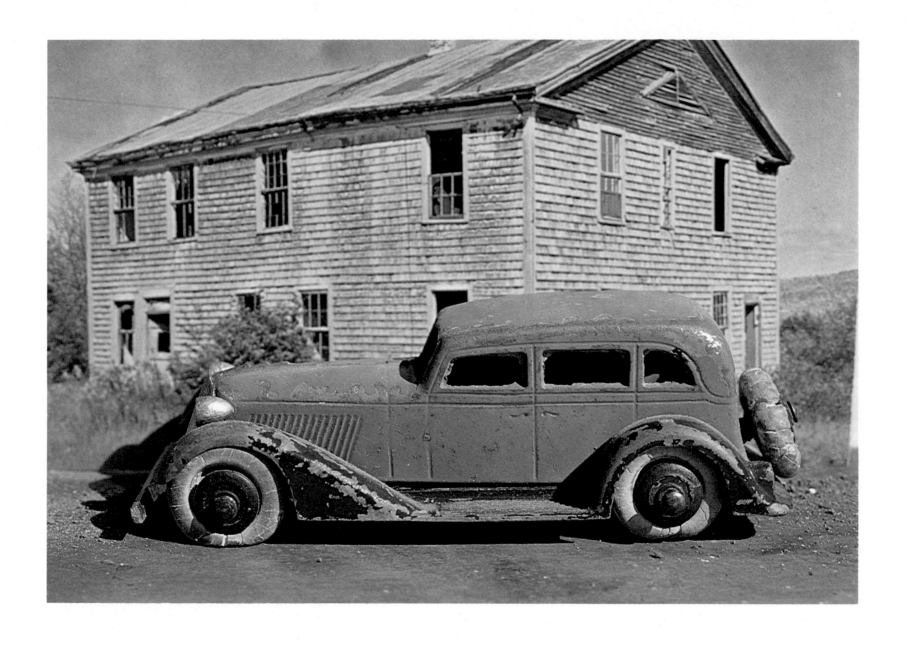

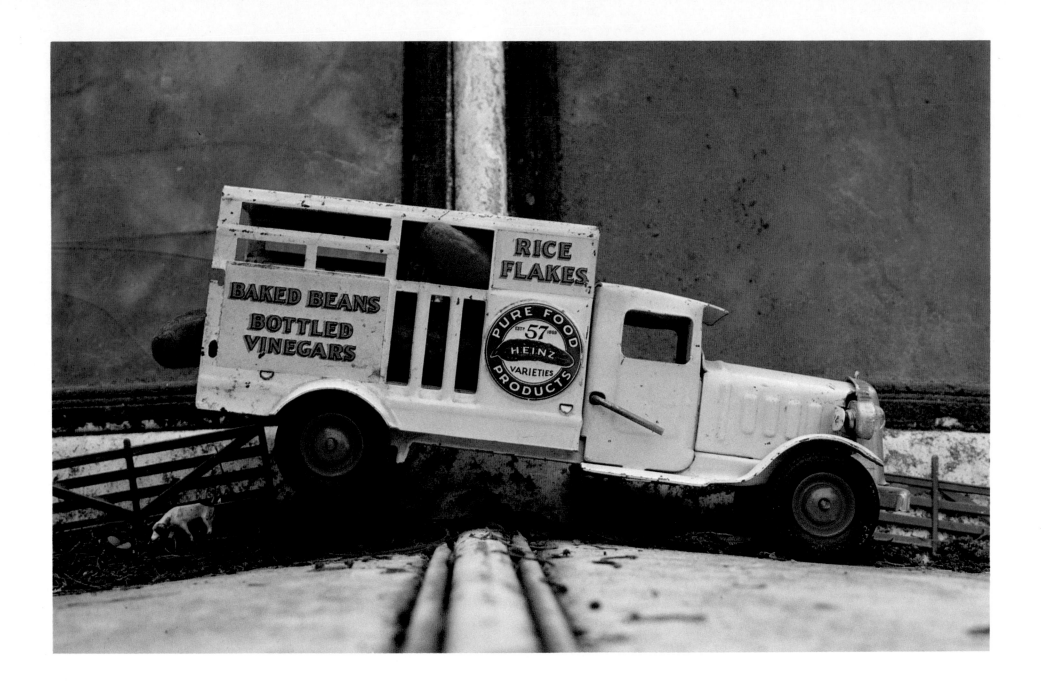

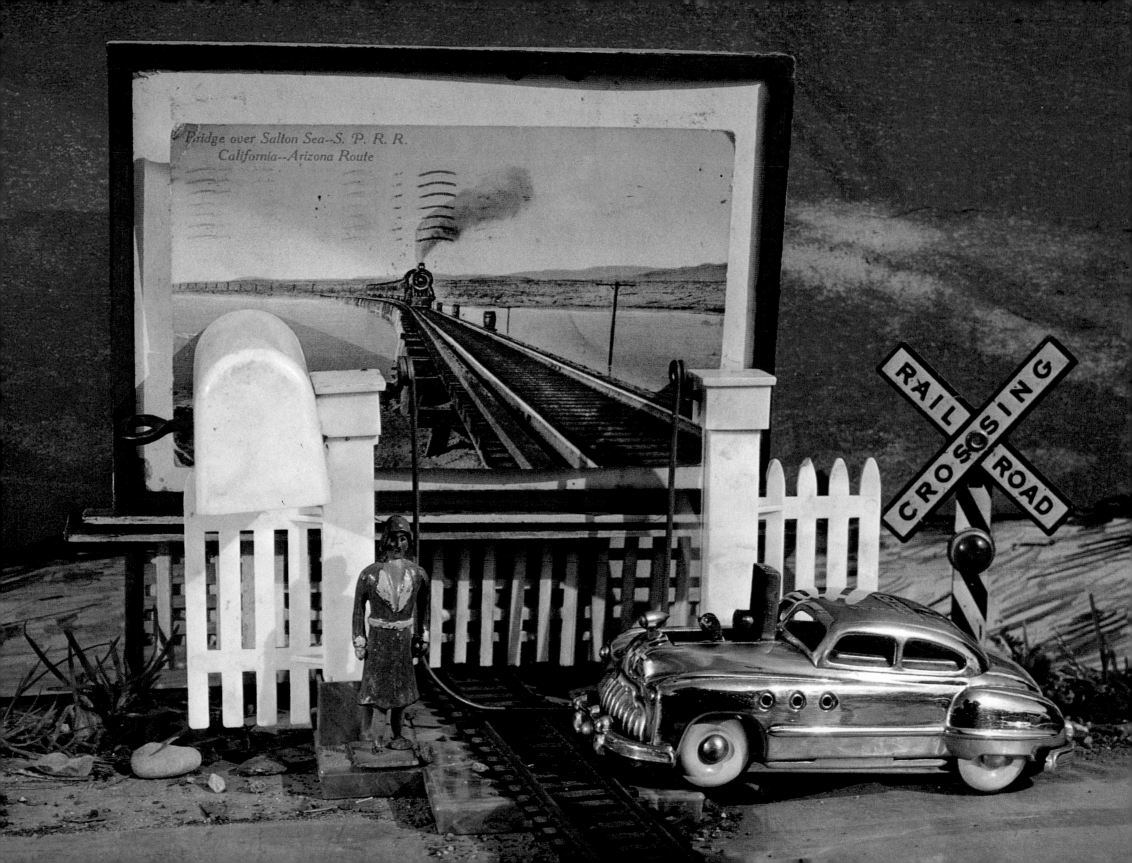

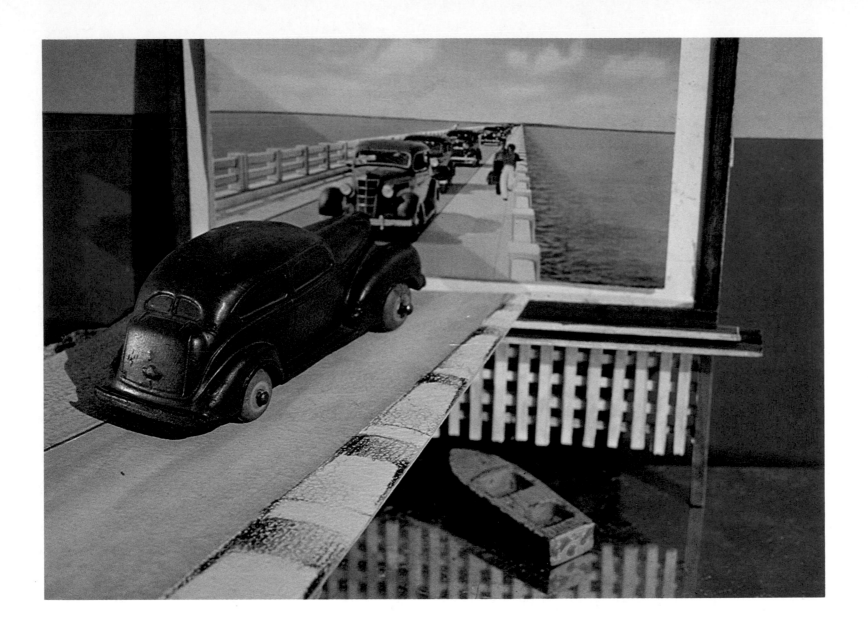

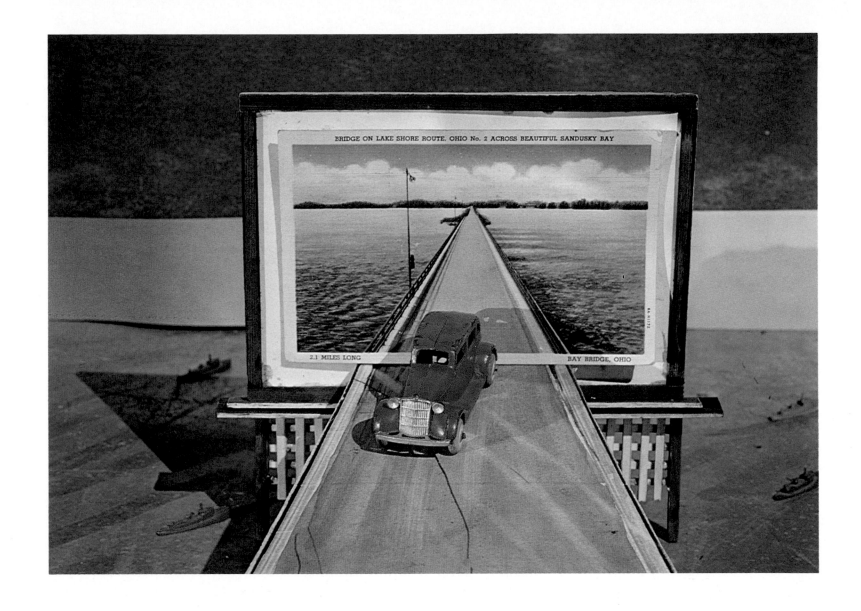

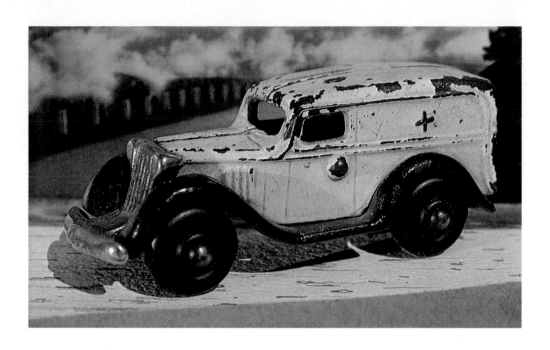

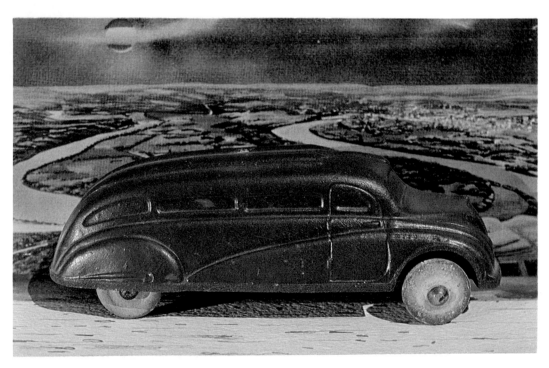

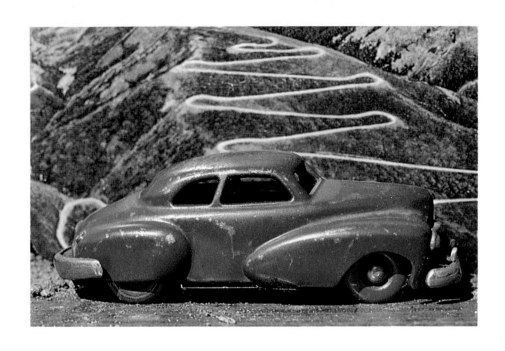

This Arcade cast-iron Greyhound Bus rolls
on white rubber balloon tires, streamlining
cross-country over moonlite roads.
Hundreds of highway miles fly by night.

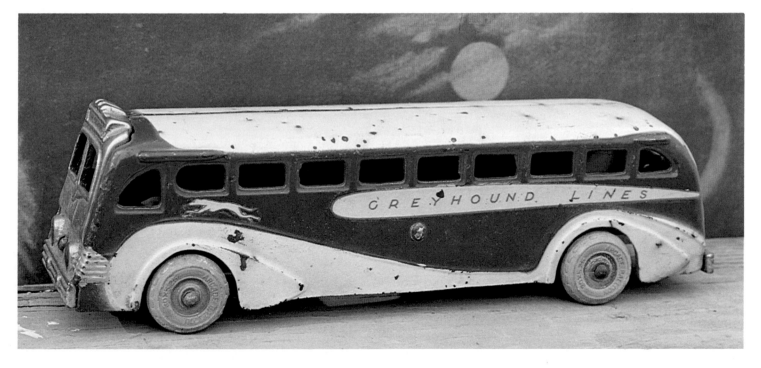

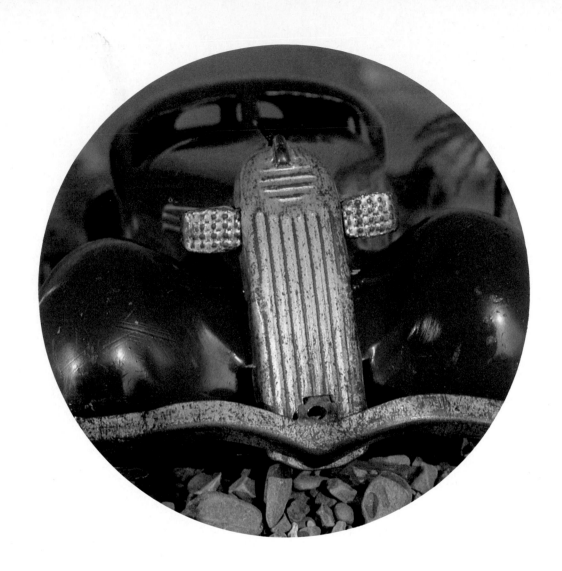

The Nomad-car-and-house-trailer craze
took off during the 1930s.
A beachcomber's dream cruises
the edges of the Sunshine State.
Palm trees shine in the windshield—
sand rolls off the tires.

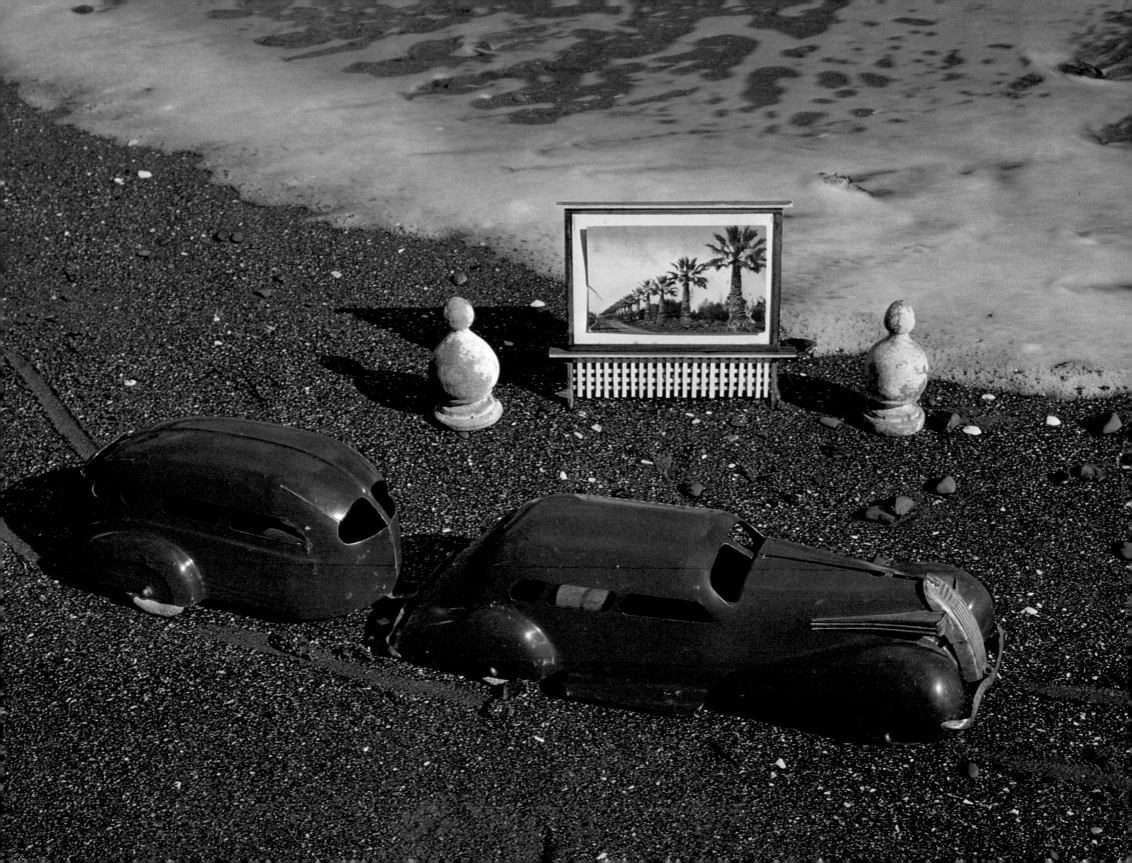

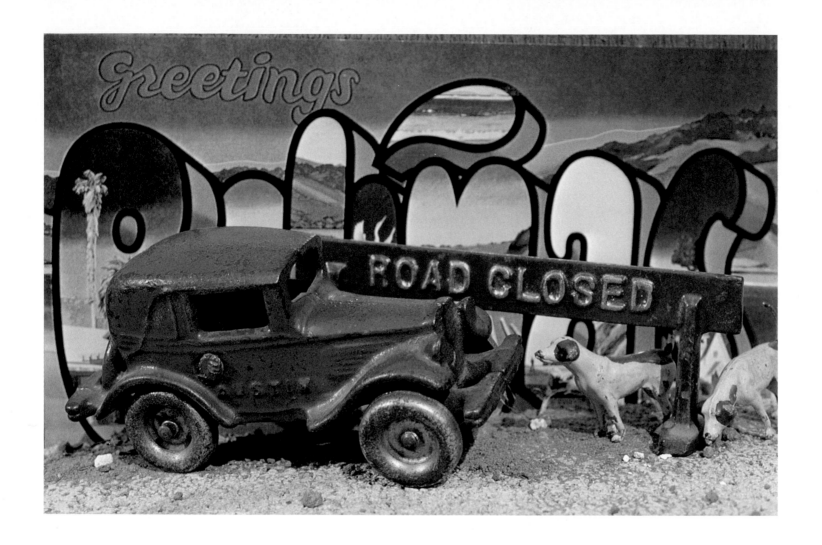

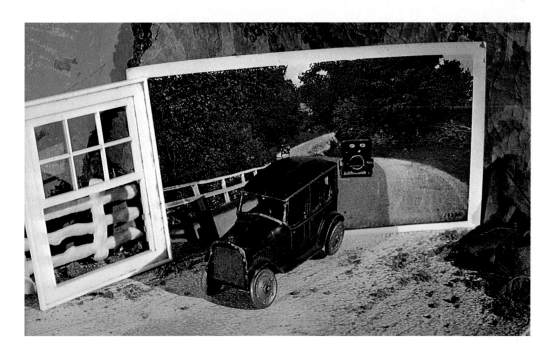

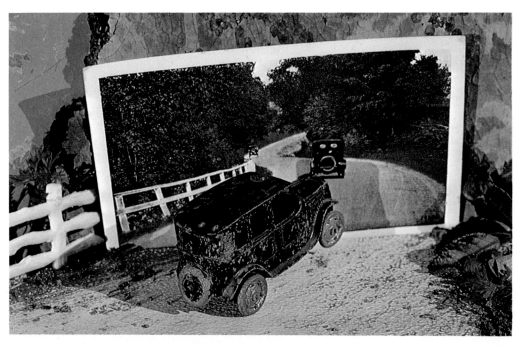

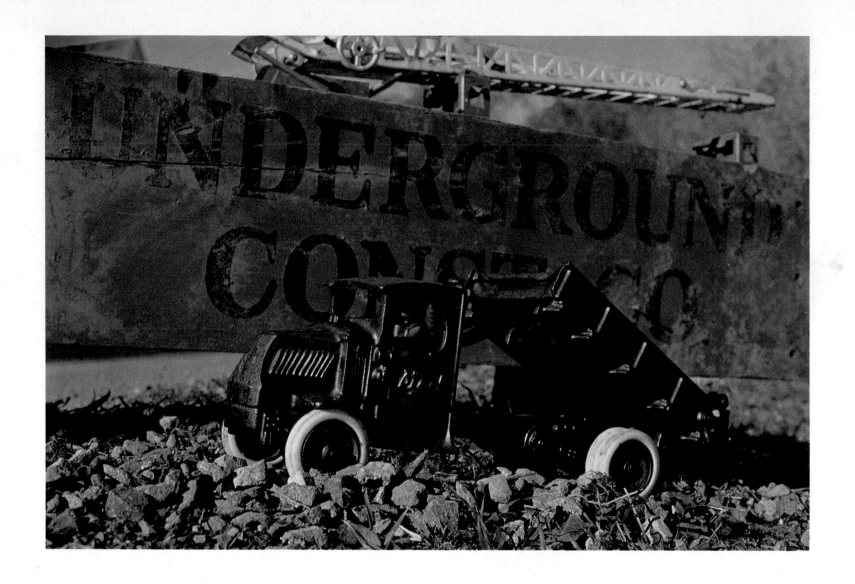

The Bulldog Mack—THE American heavy-duty truck,
chain-driven, with cast-steel wheels, solid rubber tires,
and a hand-operated klaxon horn—powers its way over
the rough ground of a real-life playground construction site,
towing a broken-down jalopy.

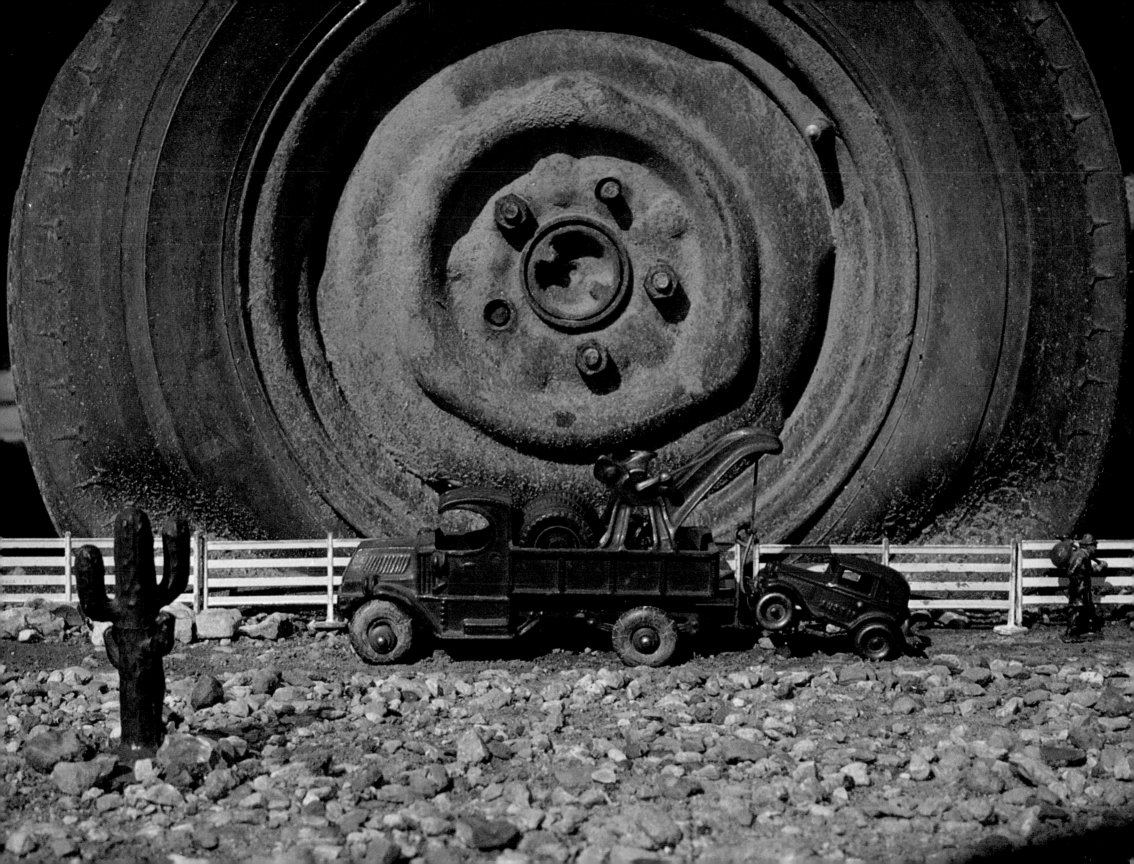

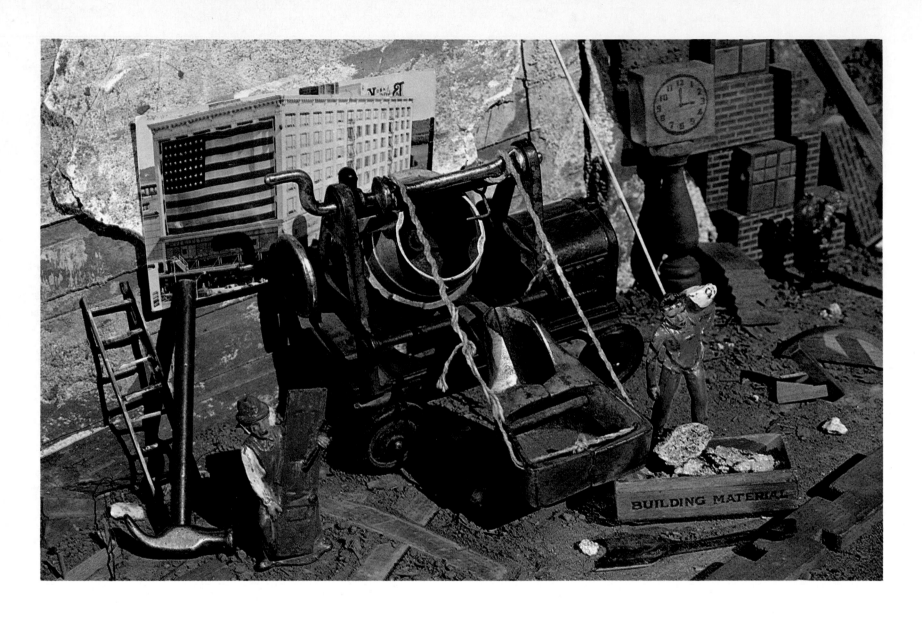

Building in the U.S.A.
Newer, bigger, better, more! Wood, glass, steel, cement!
The mixer rumbles, swishes, slurps, plops.
"Looks like the old neighborhood before they tore it down."

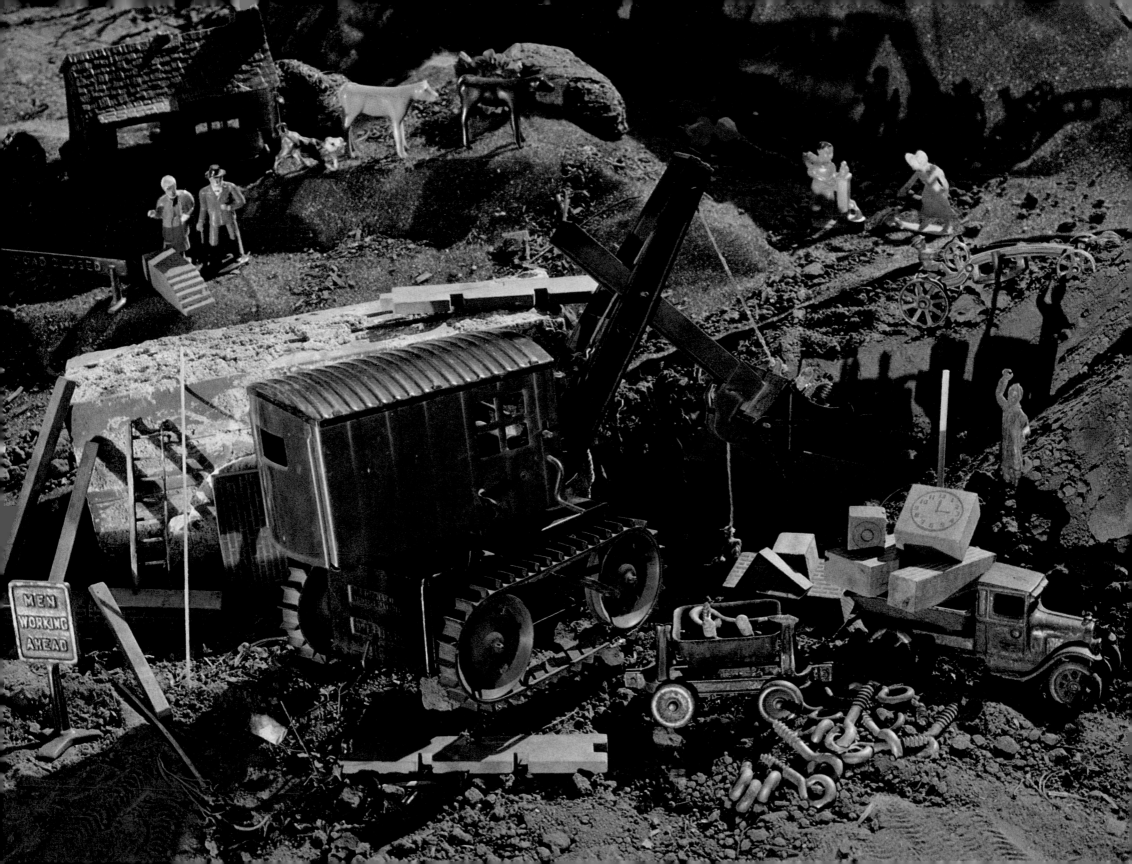

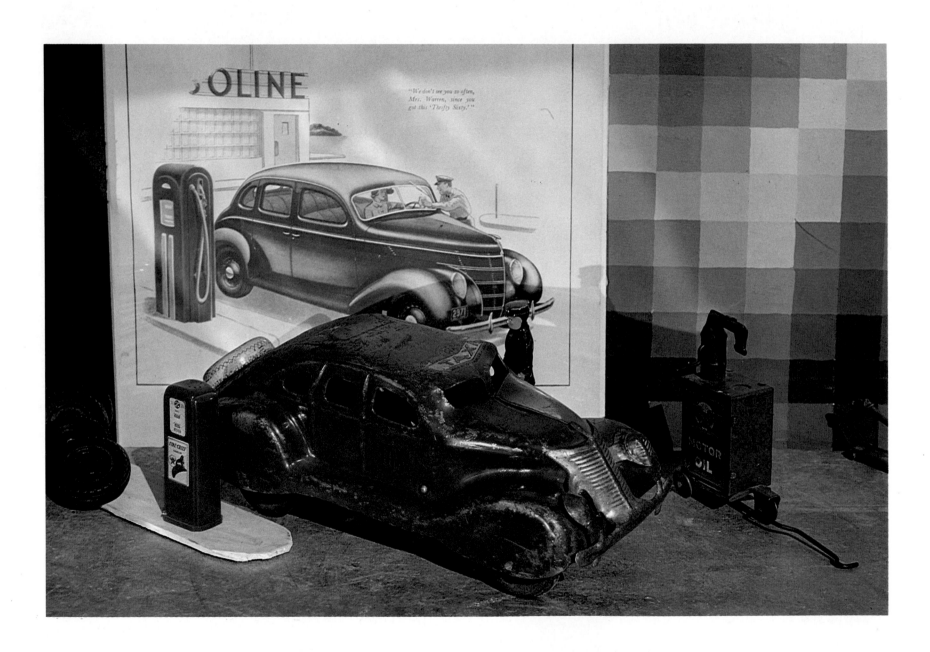

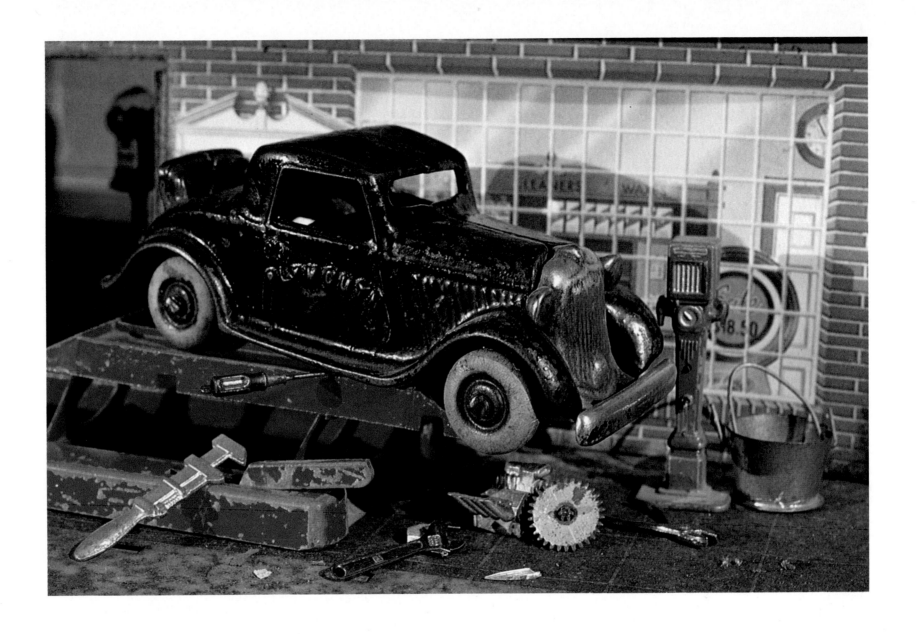

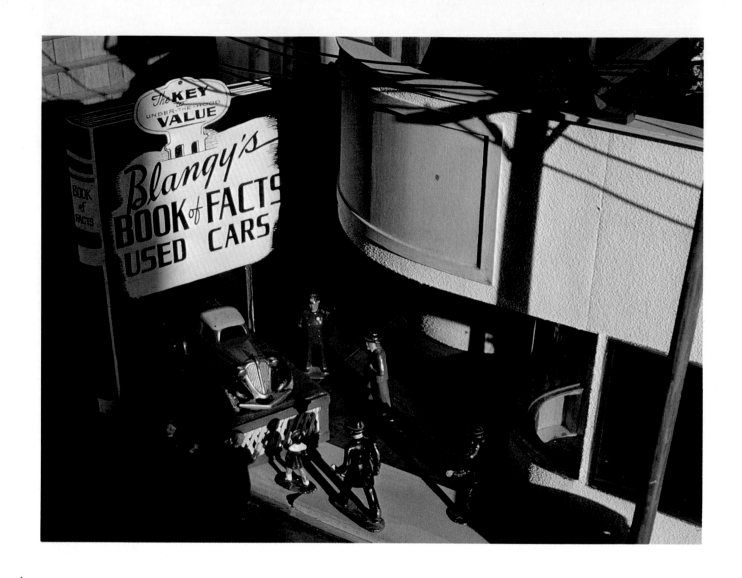

Nighttime window shoppers browse around Blangy's checking out this week's "Spotlight Special"—a sporty, two-tone Terraplane coupe.

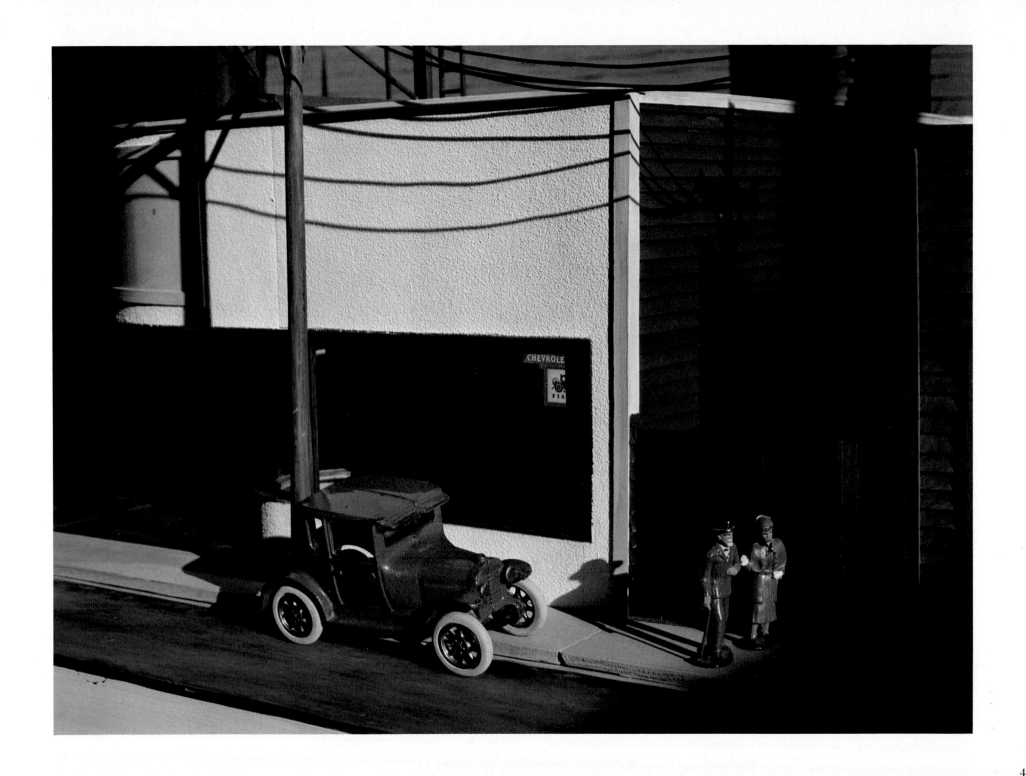

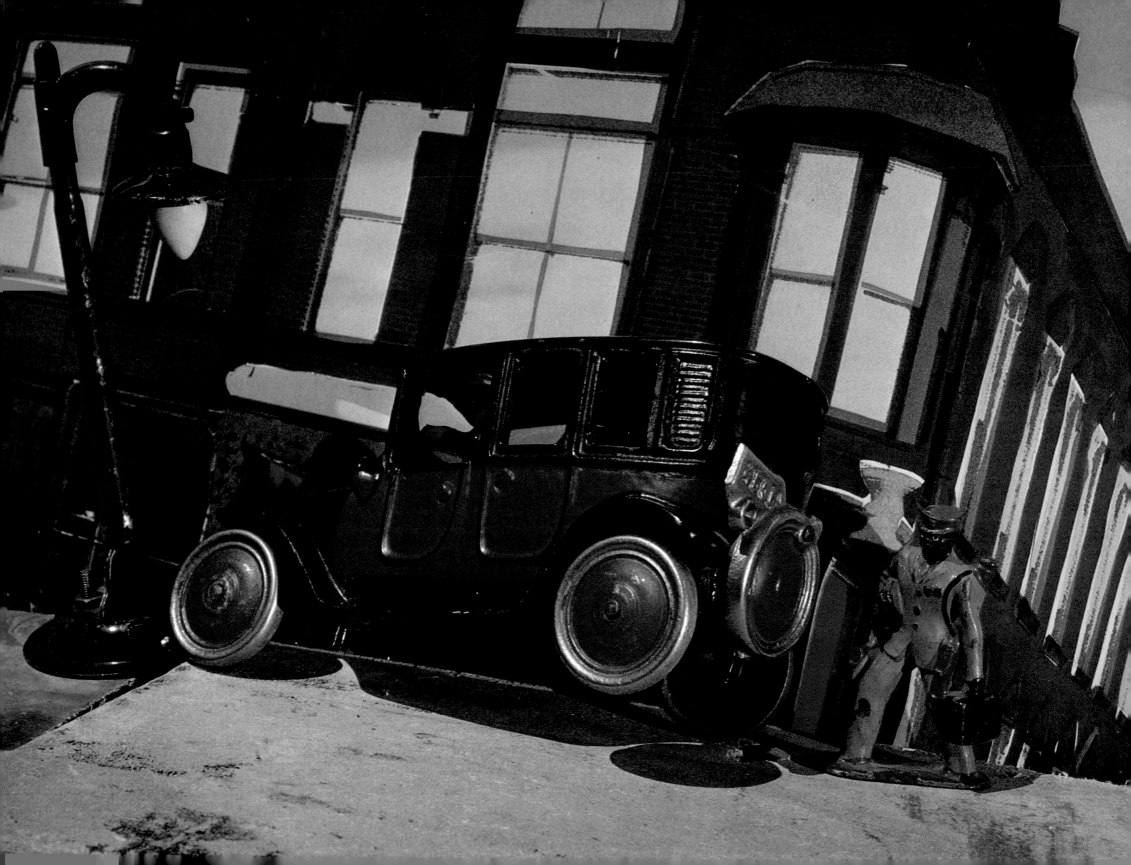

Taxi! Taxi!
A Skyview Custom DeSoto Yellowcab with a sunroof over the backseat stands ready to pick up a fare.
Cast-metal commuters troup toward their destinations. "Where to, Mac?"

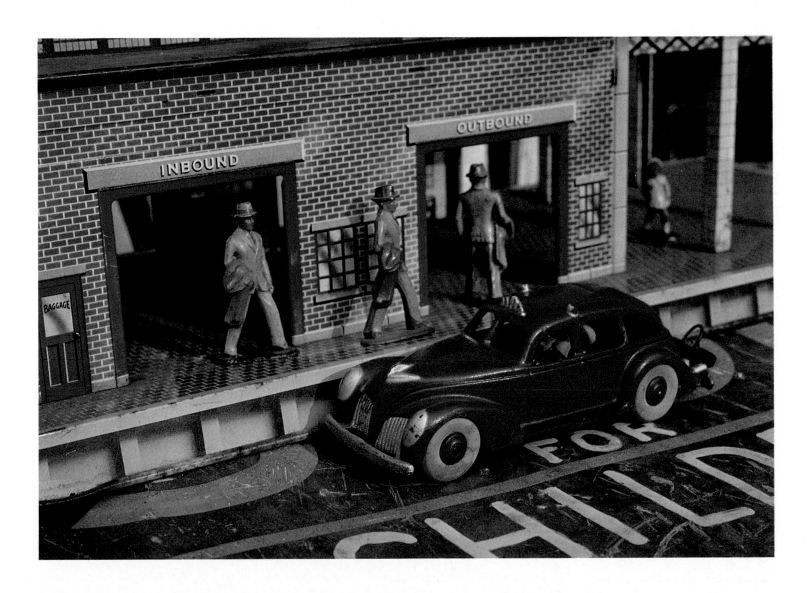

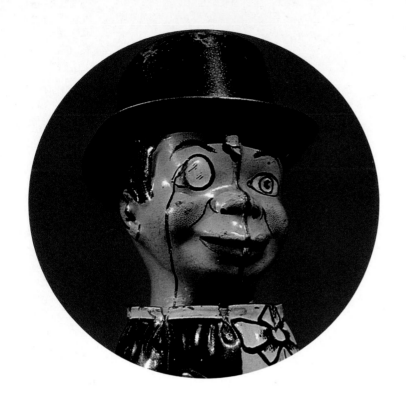

Classy Charlie McCarthy, clad in top hat,
tuxedo and monocle, master of the smartalecky comeback,
darting helter-skelter in his Benzine Buggy.
Head spinning halfway around, he tips back:
"I'll mow you down!"

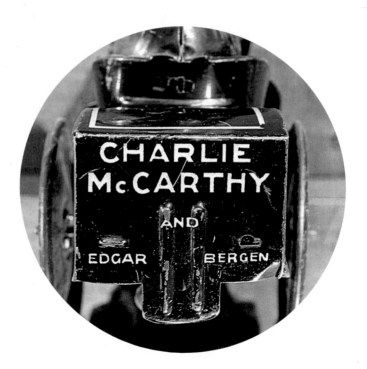

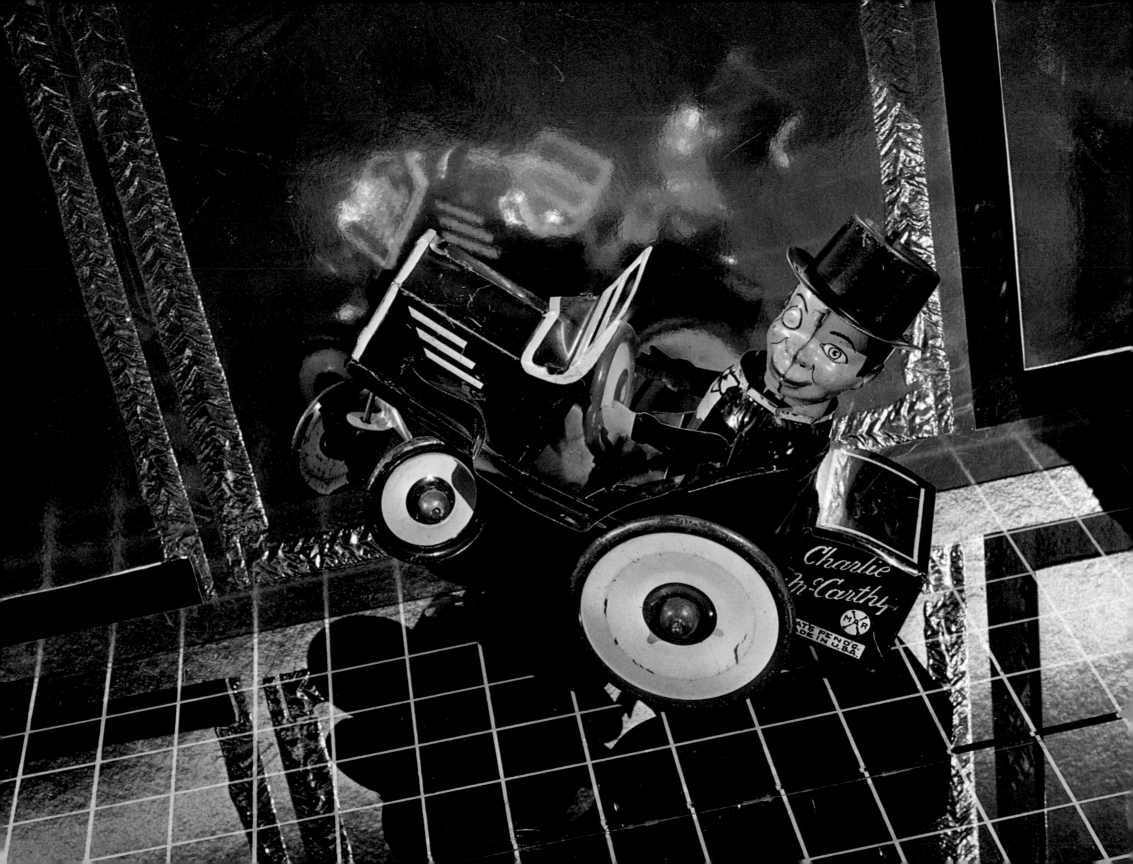

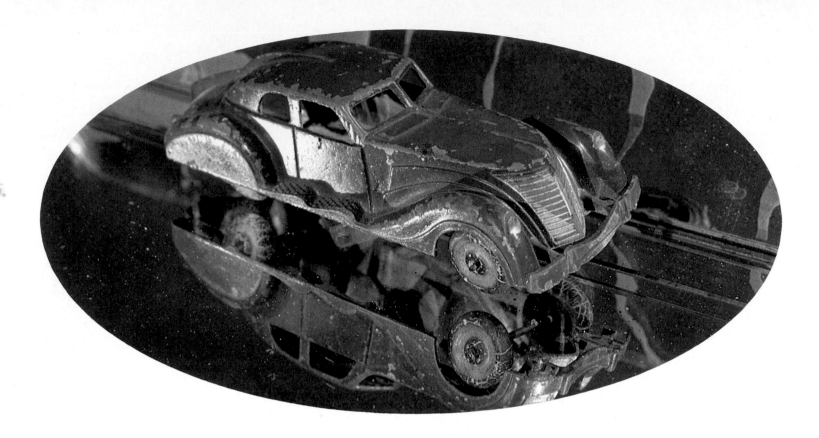

Mirrored images of teardrop deco coupes and
long-limbed ladies reflect sleek, flashing elegance.

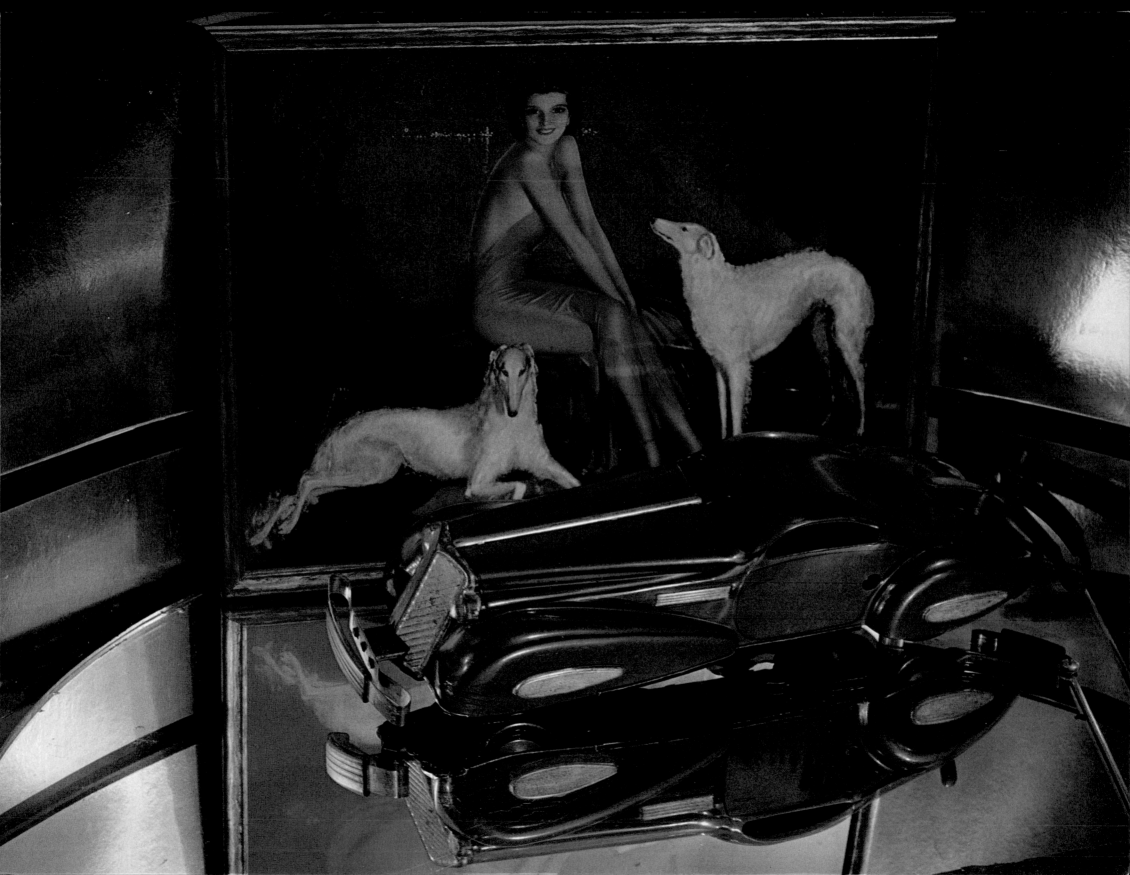

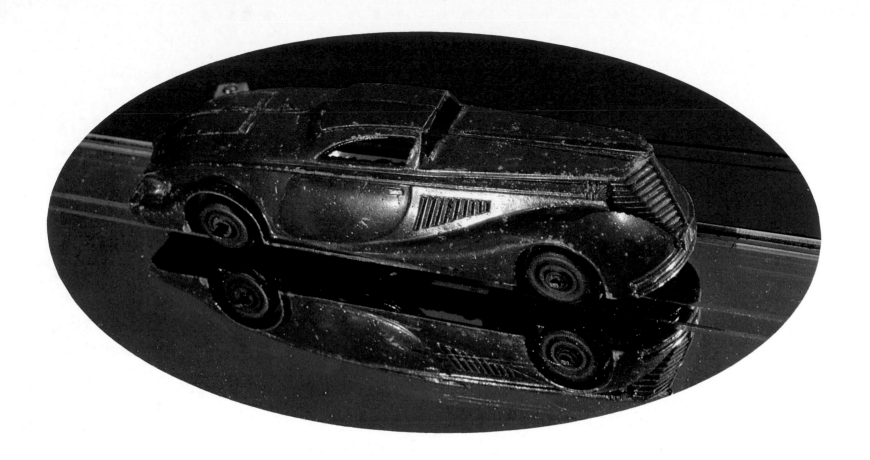

A mysterious Manoil steals silently over glassy blue streets.
Its red, soaring, streamlined, sculptured lines aren't modeled
in the likeness of any auto in this down-to-earth world.

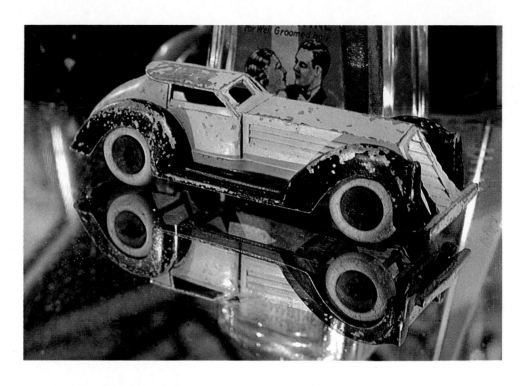

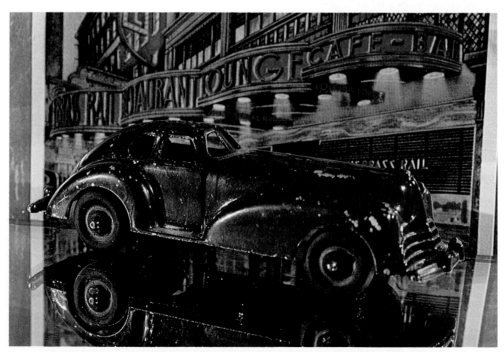

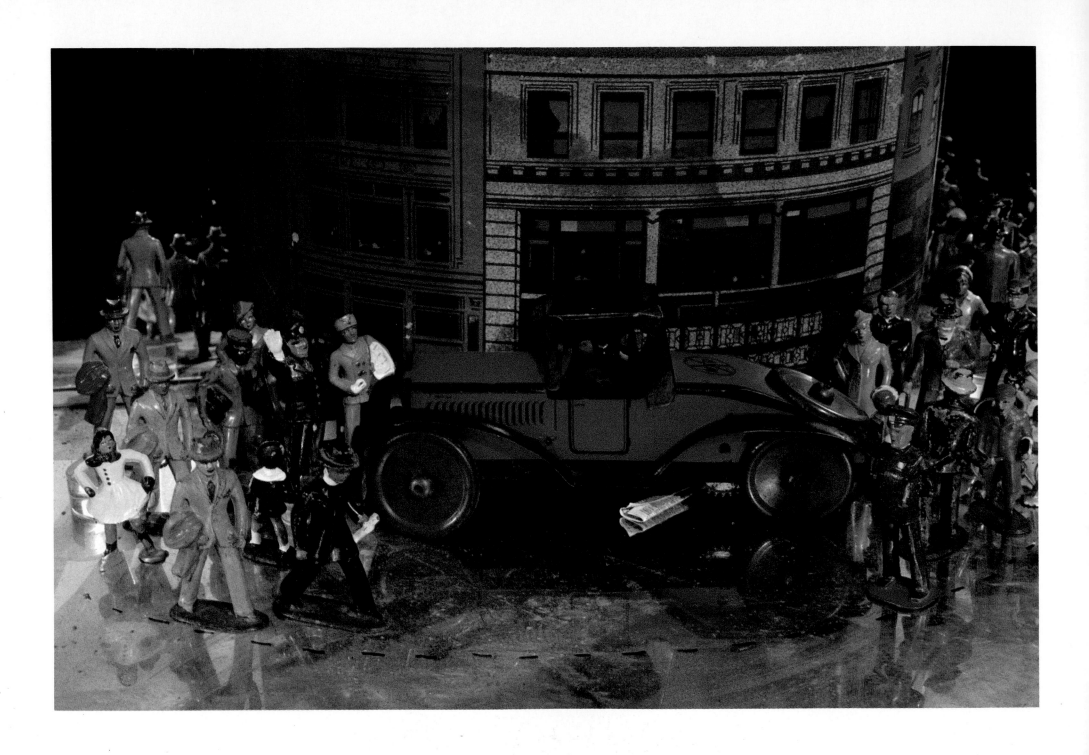

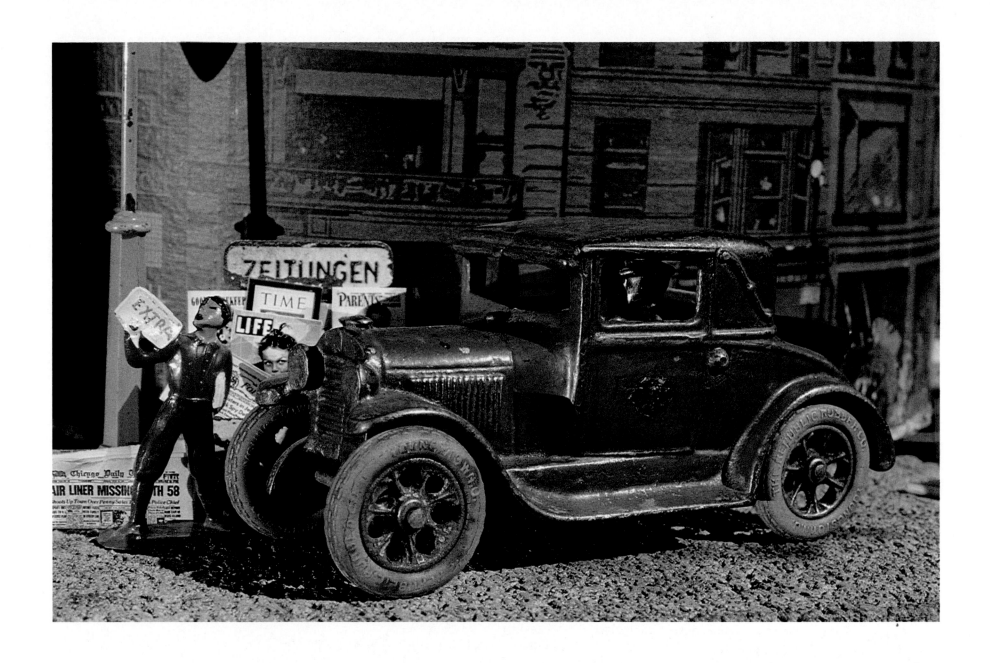

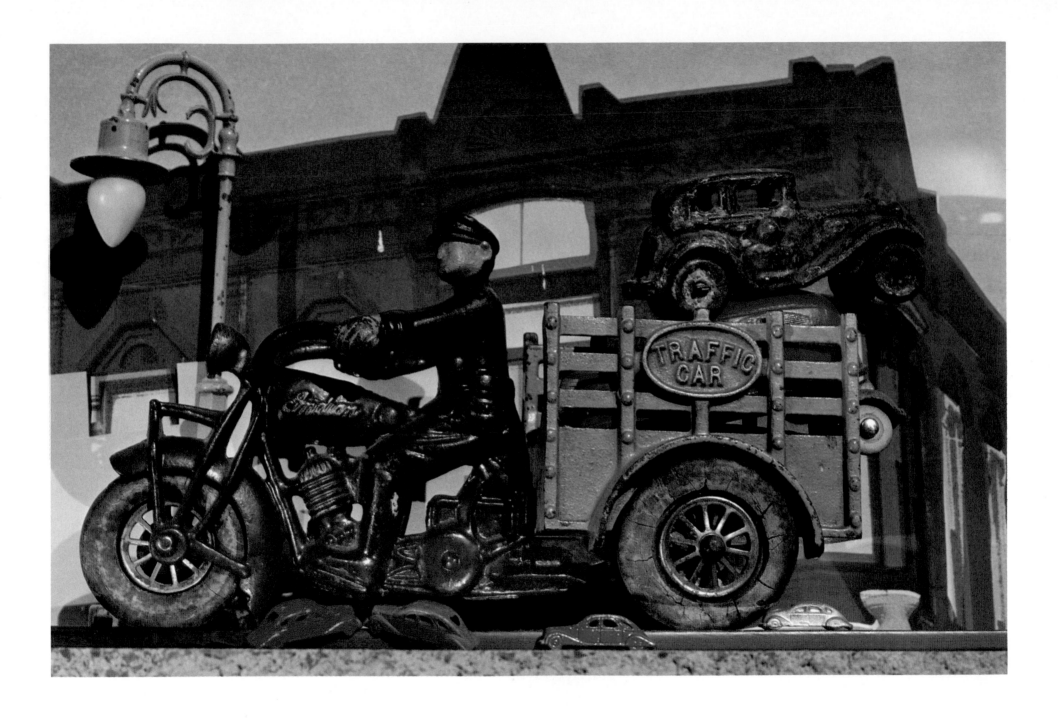

In the days of the neighborhood policeman, he was what you wanted to be when you played cops & robbers.
And though this officer has a stern upright posture and a high-bridged military-style cap,
the sinister patch over his eye is probably due less to design than to a missed brush-stroke at the toy factory.

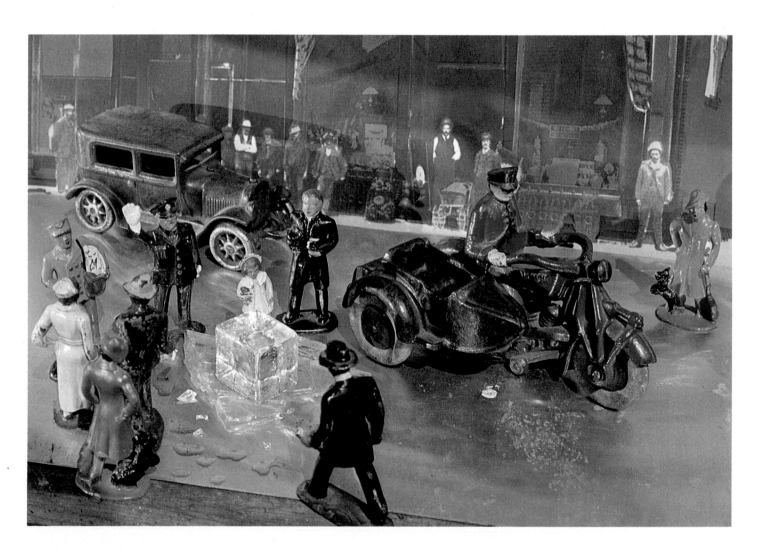

Dick Tracy, Crime-Stopper, takes 'em all on—
the whole freakish gallery of crooks: Prune-Face;
Fly-Face; No-Face; The Rodent; The Mole; B.B. Eyes;
and Measles. Armed with his badge, fists, gun
and his two-way, All-American-gadgetry wrist radio,
he is prowling the city streets with his cronies.
The car, a 1949 Hudson, painted New York City Police Green,
comes complete with a battery-operated blinking teardrop red light,
PLUS a built-in siren that crescendos to a wail as
the wind-up car ka-reeens across the floor.

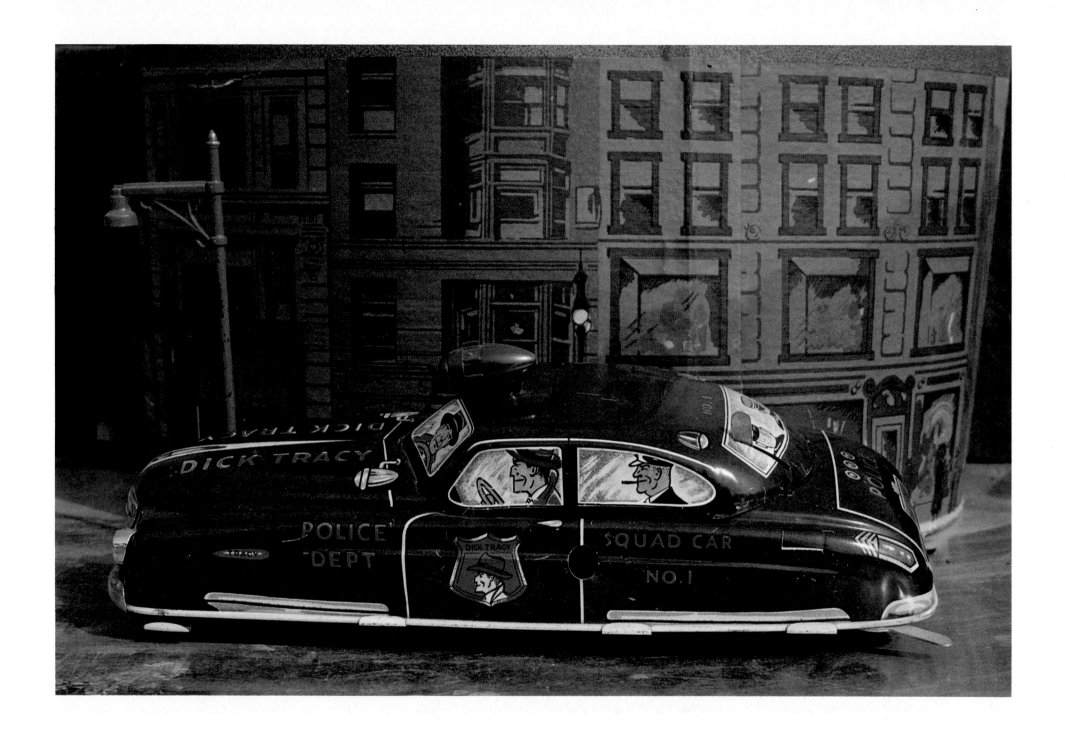

Ra-Ra. "Enter at your own risk." *23 Skidoo.*
A foursome of flappers arrives at the Big Game in a '20s Stutz
Custom Rumbleseat Roadster sporting, "Dig this crazy car" slogans from the '40s.
The Stutz is kind of classy for the catch-phrase craze . . . a Ford would be more like it:
a real Tin Lizzy—99 and 44/100% pure tin. "If you can read this you are too darn close."

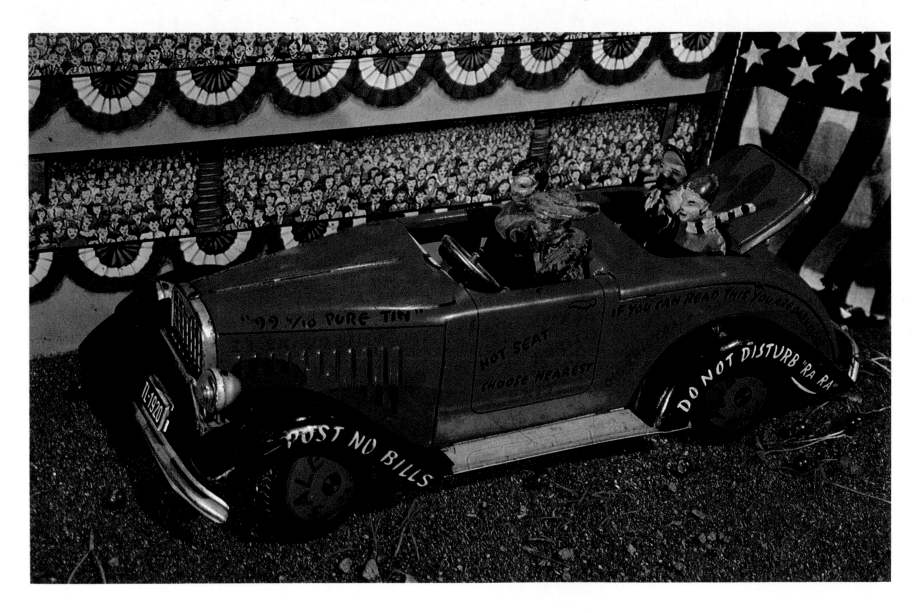

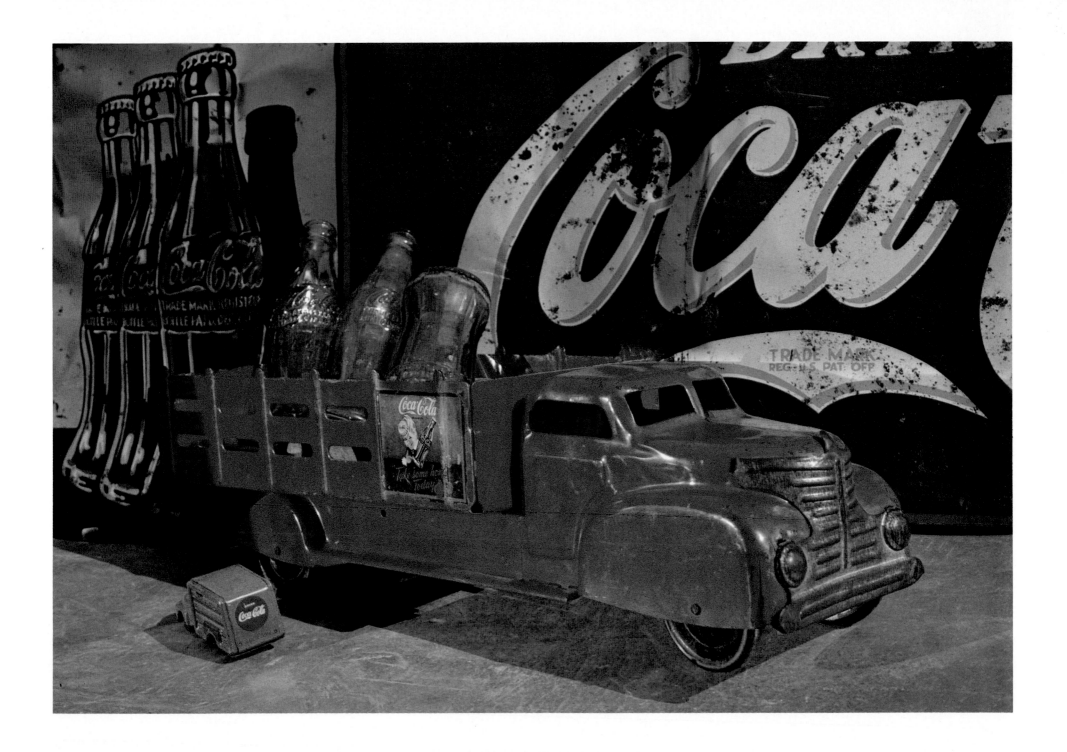

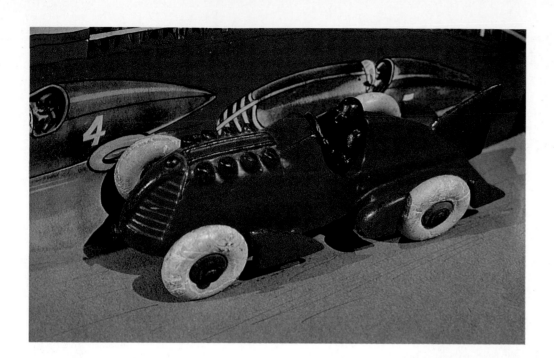

Osky wow wow!
This fun-loving twosome is having the time of their lives banging around at the amusement park speedway, scooting in their Fleet-Wing Dodgem bumper car.

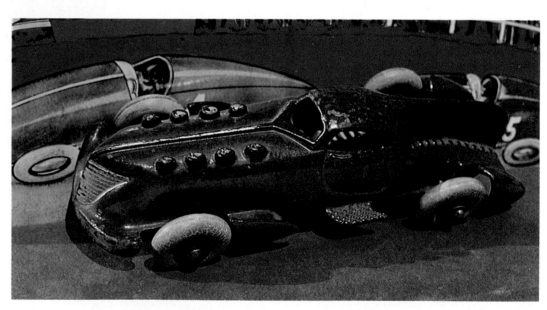

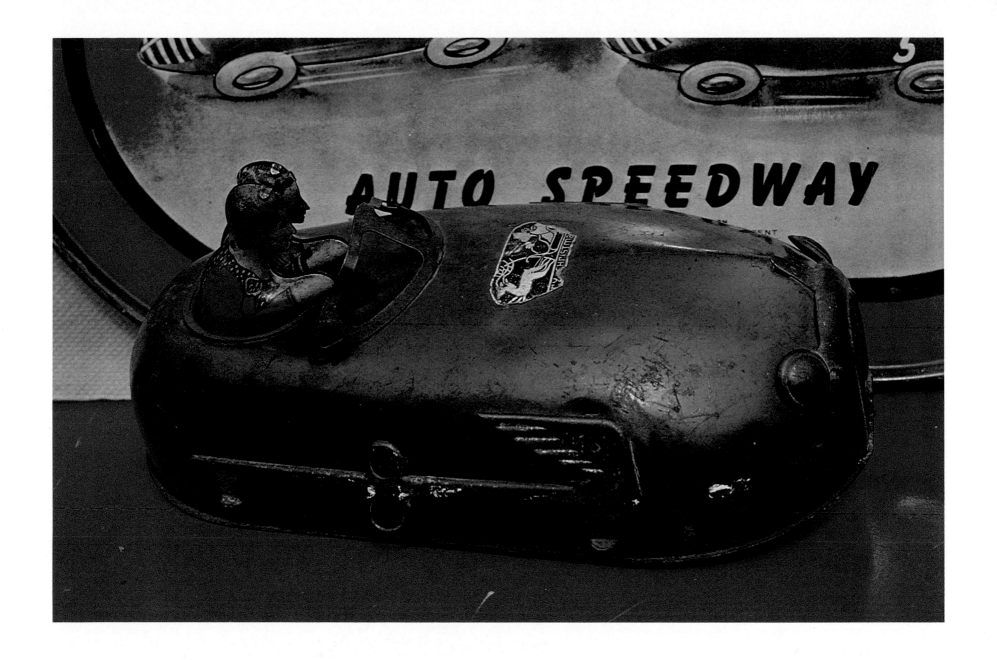

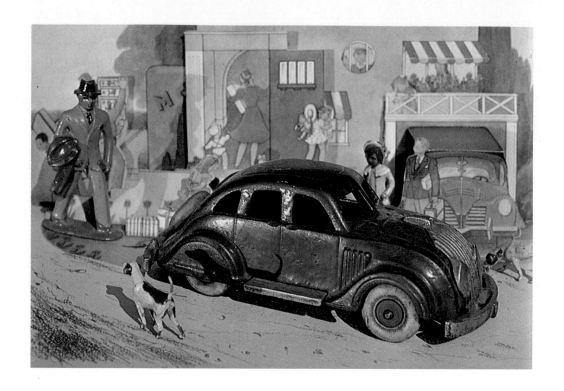

The Joneses are moving into their brand-new
pink & blue Jolly Jump-Up House.
Parked in the driveway, what appears to be
a red Volkswagen, isn't—it's a 1934 Chrysler Airflow.
This cast-iron Hubley has a unique construction:
the chassis, which incorporates the nickel-plated grille,
running-board, back bumper and sparemount, is all one
piece held in place by the white rubber spare.
Everything appears hunky-dory for this nice family.
But wait—who's this strange man with the wide-brimmed hat
marching onto the scene?

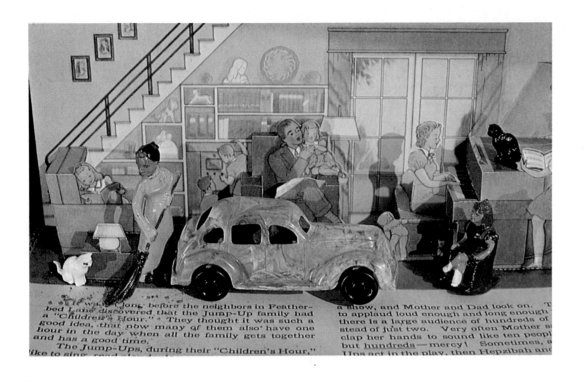

It was not long before the neighbors in Feather-bed Lane discovered that the Jump-Up family had a "Children's Hour." They thought it was such a good idea, that now many of them also have one hour in the day when all the family gets together and has a good time.

The Jump-Ups, during their "Children's Hour," like to sing, read, play games

a show, and Mother and Dad look on. T to applaud loud enough and long enough there is a large audience of hundreds of stead of just two. Very often Mother s clap her hands to sound like ten peopl but hundreds—mercy! Sometimes, Ups act in the play, then Hepzibah a

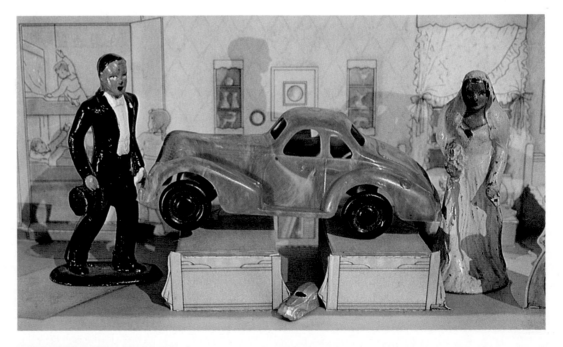

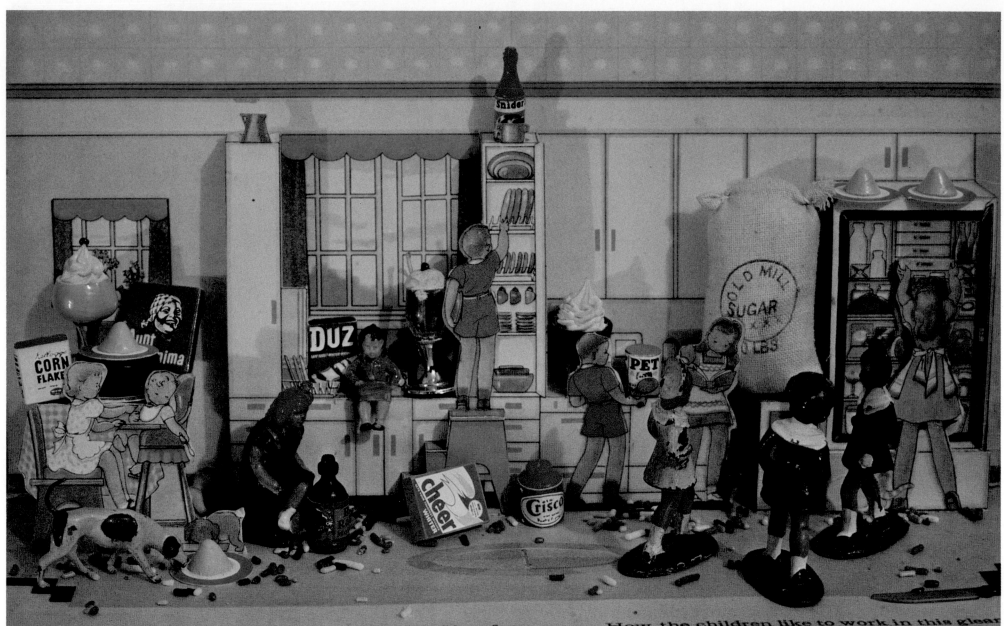

Mother's day off! That means a holiday for Mrs. Jump-Up. To the Jump-Up children, it means a special treat, for they are given the freedom of the kitchen and allowed to get their own lunch when Mother is out. Mother insists that they have milk and fruit, but aside from these they may eat any- [...] "Hurray!" cried the children.

How the children like to work in this gleam[ing] sunny kitchen! They have all had a share in [keep]ing it lovely and so, of course, they do their [...] keep it lovely. It was Judy who helped [...] sew the curtains for the windows. Janet [...] put all the knives, forks, spoons and [...] drawers and cabinets. The twins helped [...]

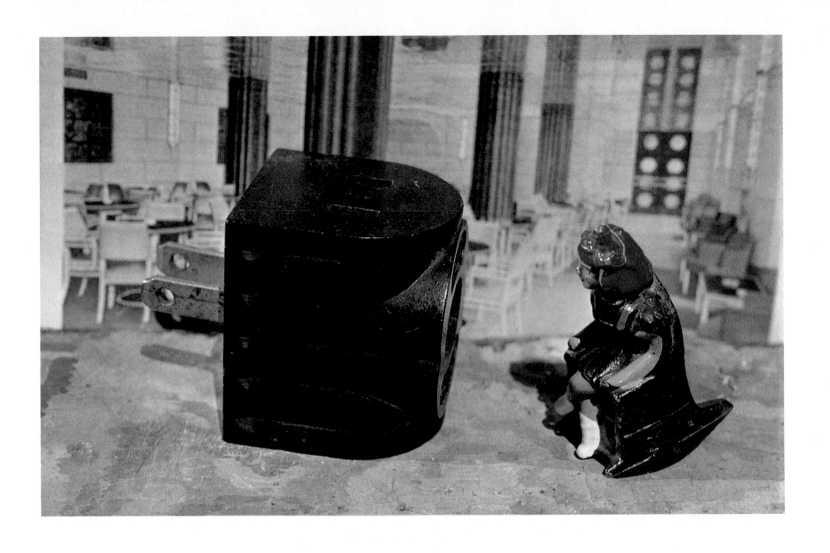

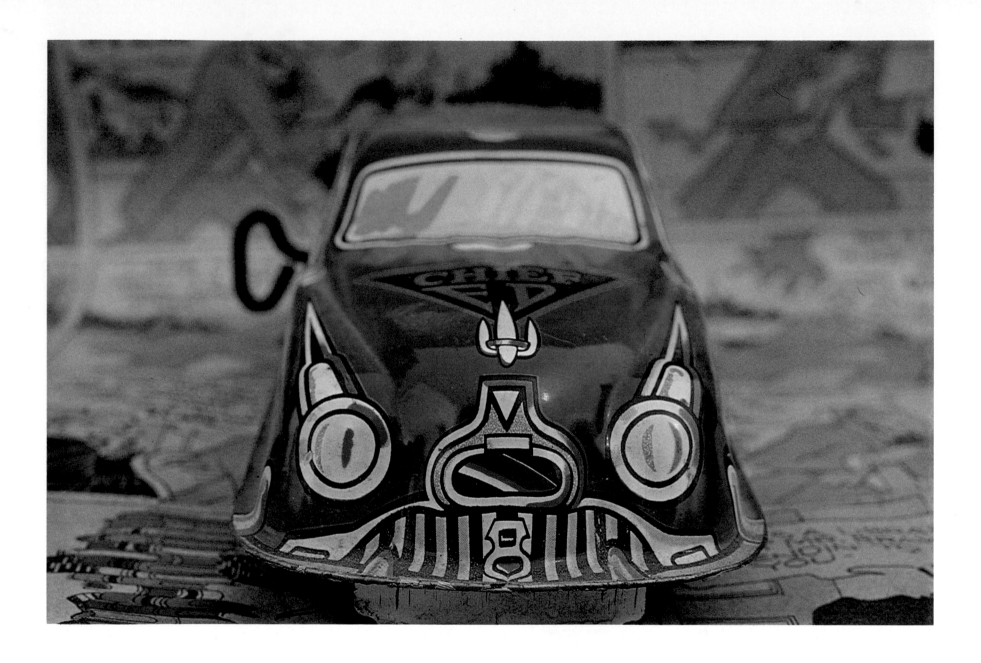

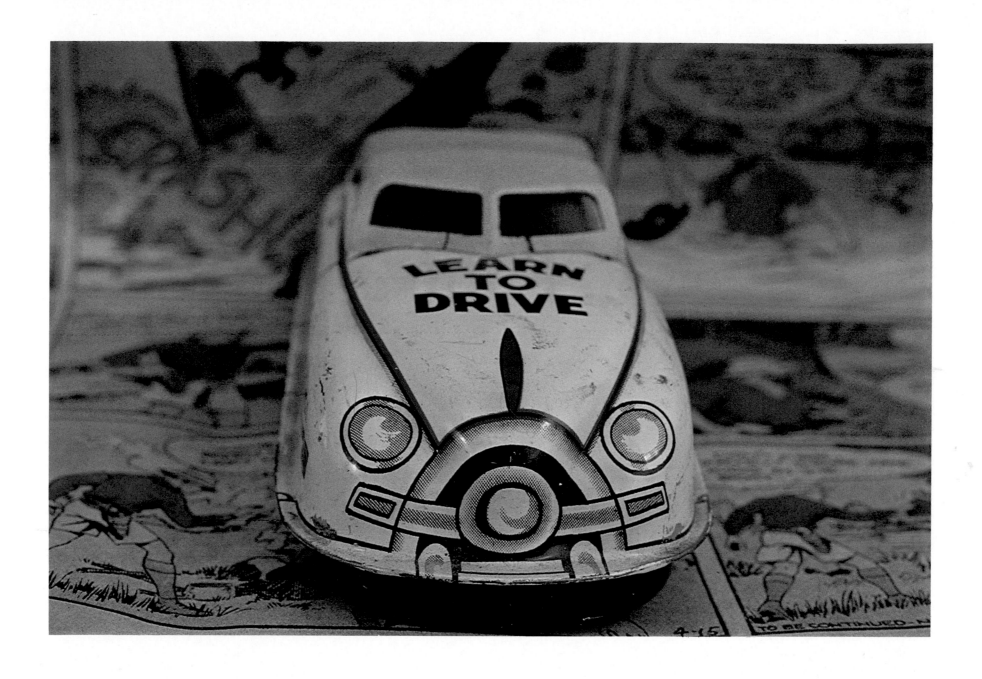

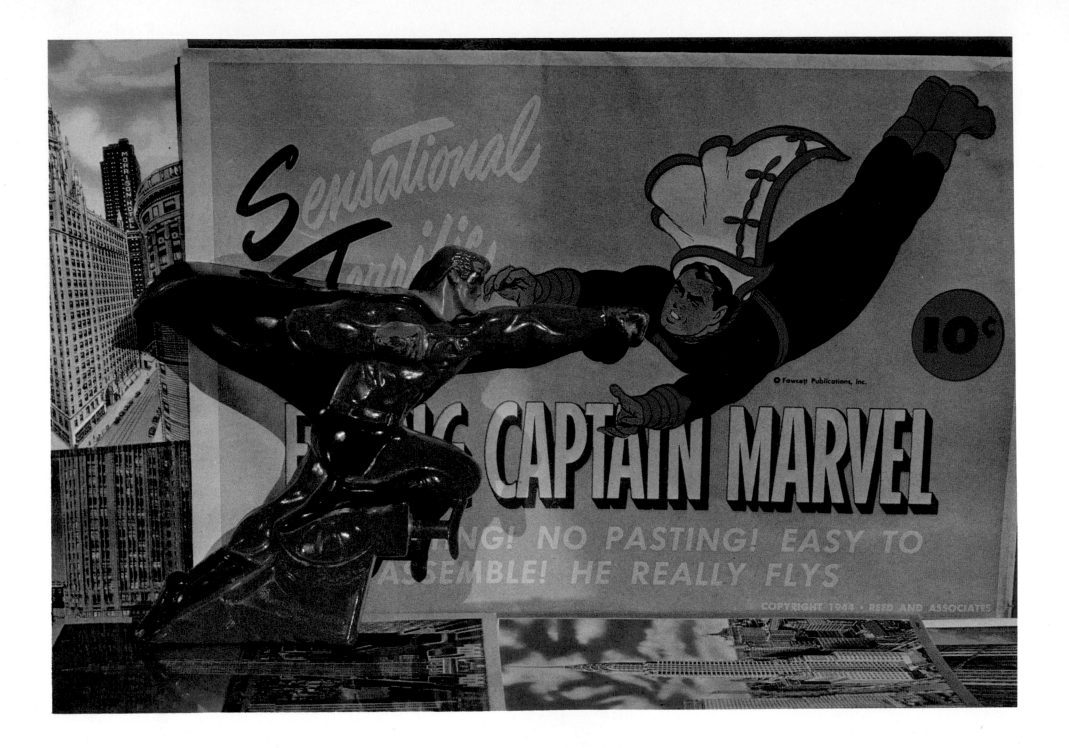

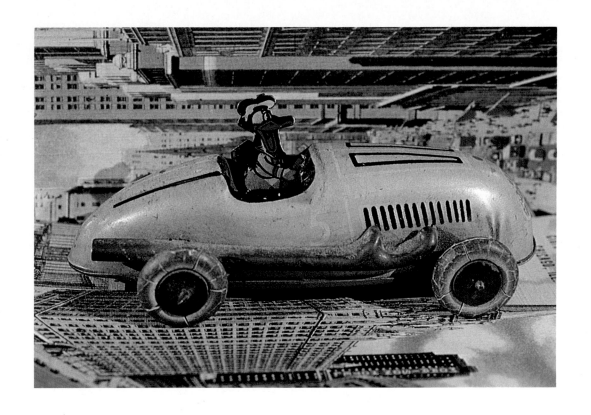

Up, up . . . and away!
Superman—disguised as a plastic water pistol —flies
high above The Daily Planet, squirting straight into
Captain Marvel's clutches. Shazzzammm!
Oh, for the days when the skies abounded with superheroes.

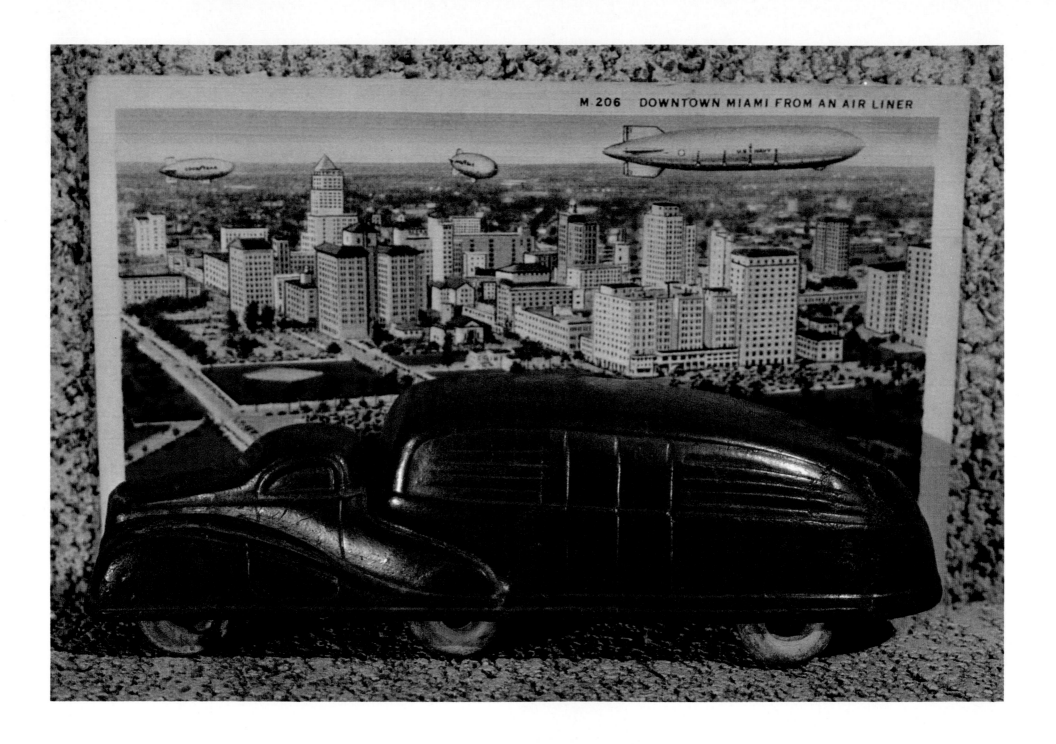

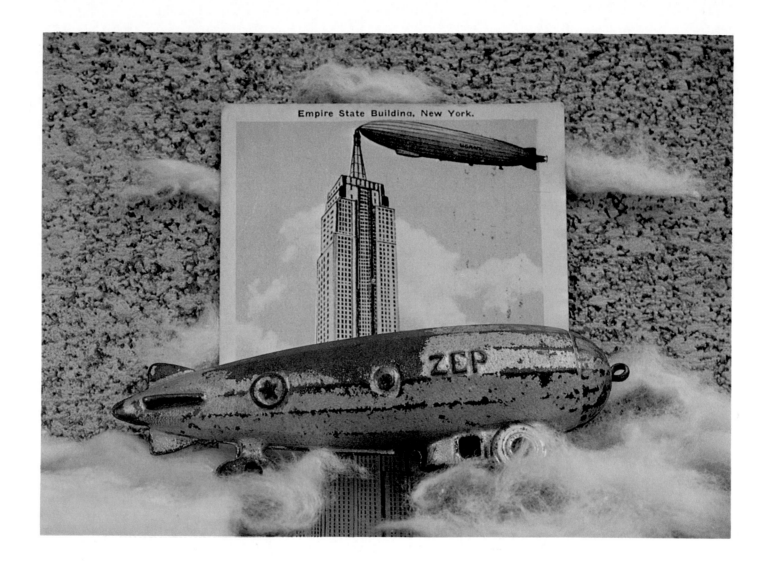

The Zeppelin, the lighter-than-air-ship, is anchored to
the top of the Empire State Building. It floats smooth
and easy like a strangely propelled silver cigar-in-the-sky.
Transcontinental travelers exit safe and sound from the
big dirigible's gondola—one-hundred-and-two stories
above the ground.

This science fiction spaceship waddles across the floor
making loud clanking-sprung sounds as the wind-up winds down.
Sparks shoot from behind and the Sunday color funnies come alive
on the lithographed tin surfaces. Buck Rogers and his lovely
girlfriend Wilma both wear Roman football spacesuits, and—
along with Dr. Huer—they forge through star-spangled space,
eager to save the universe from all evil forces.

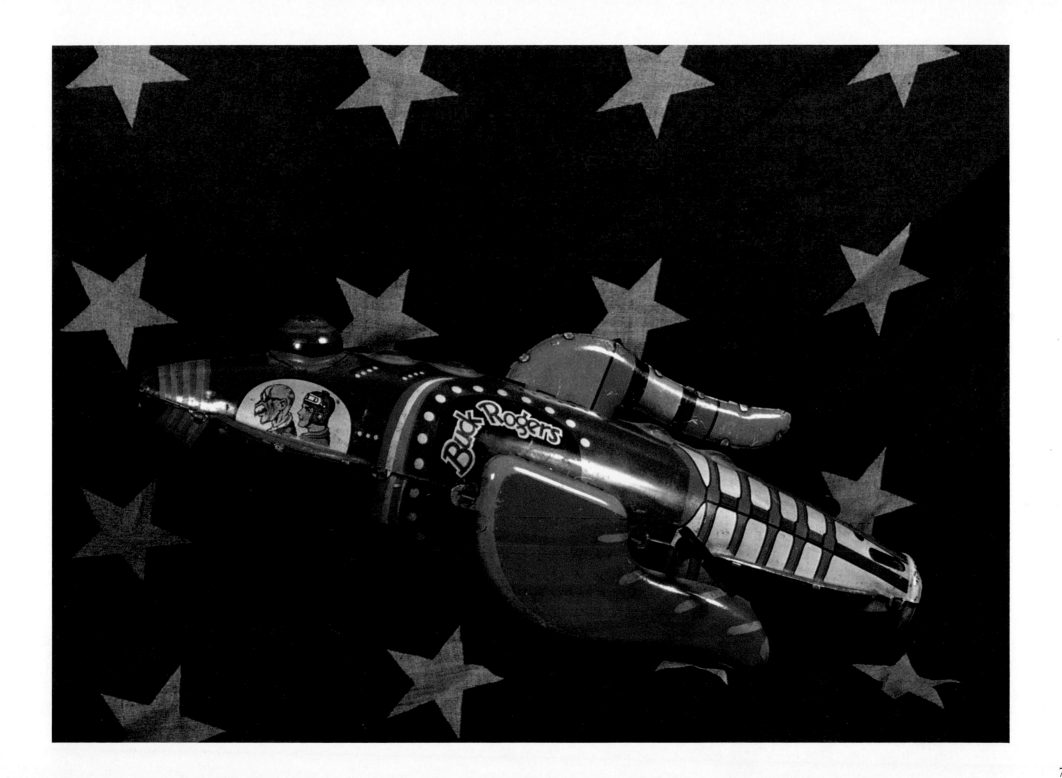

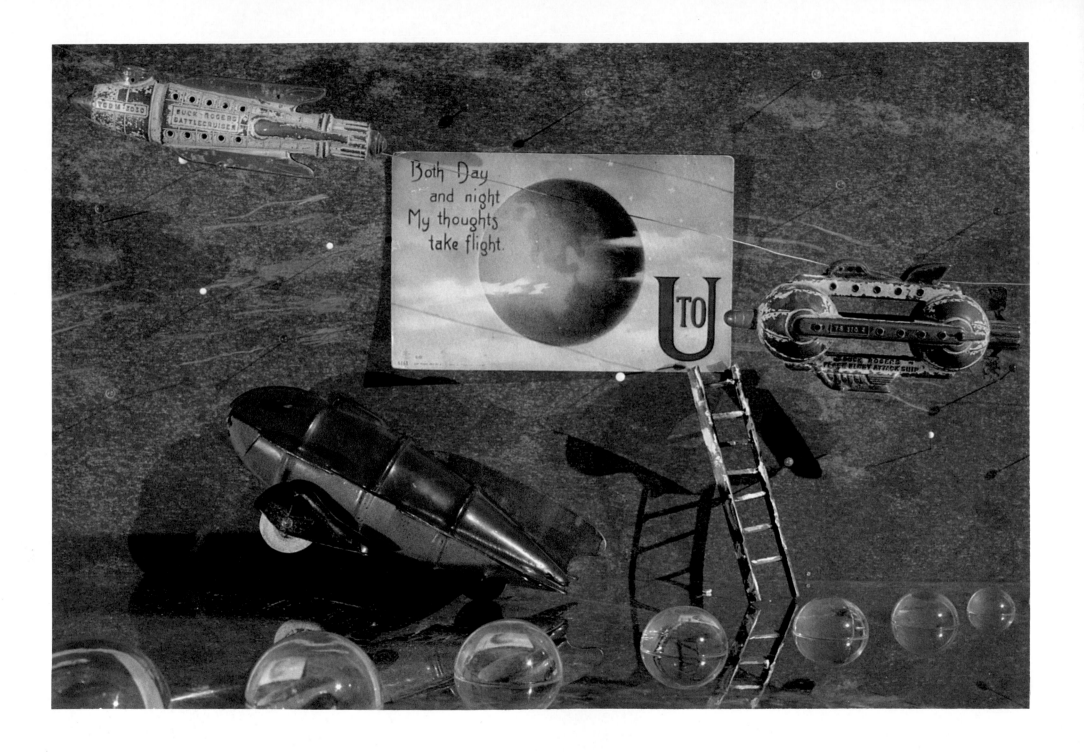

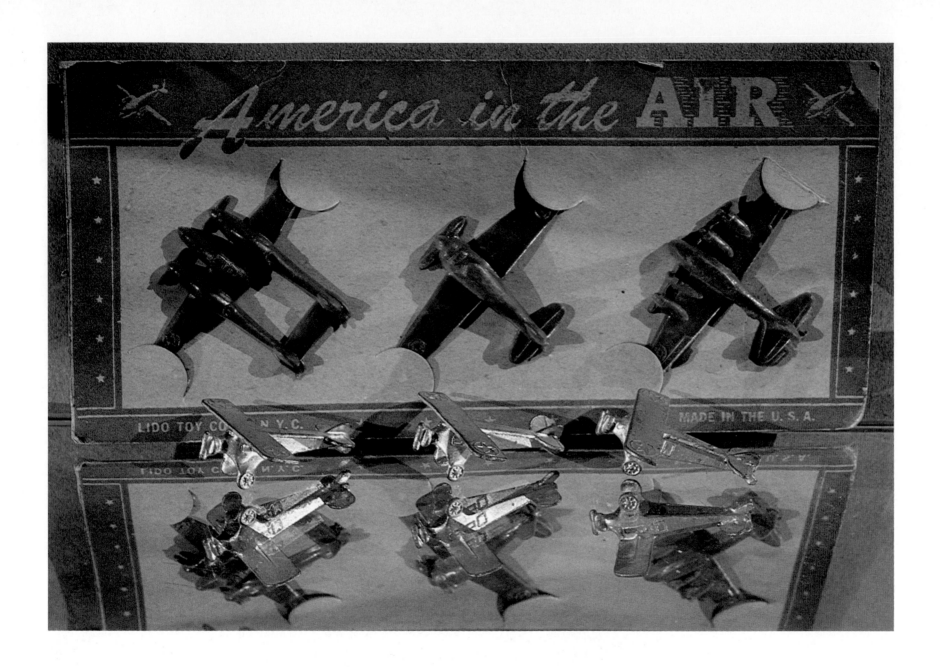

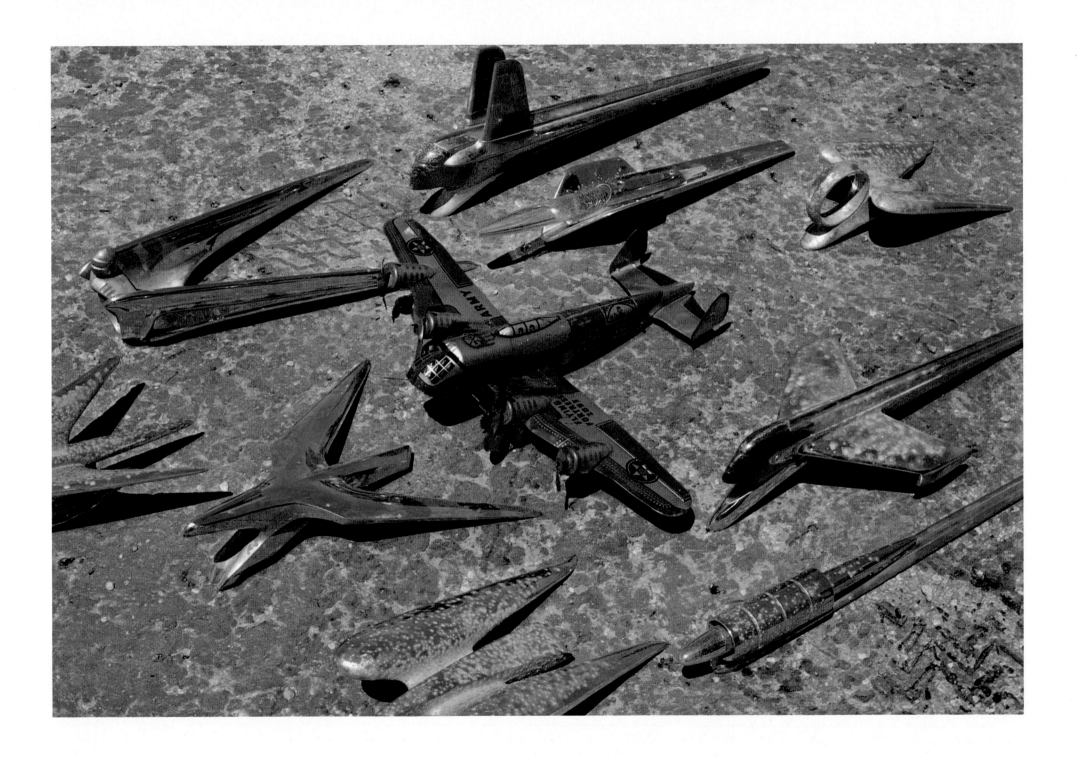

Is it a bird? Is it a plane?
Never! It's an autogyro—*not* a helicopter.
The autogyro's rotor isn't motorized;
it can't hover in midair—
but it can *buzzzz* over the backyard garden patch
like some searching mechanical dragonfly.

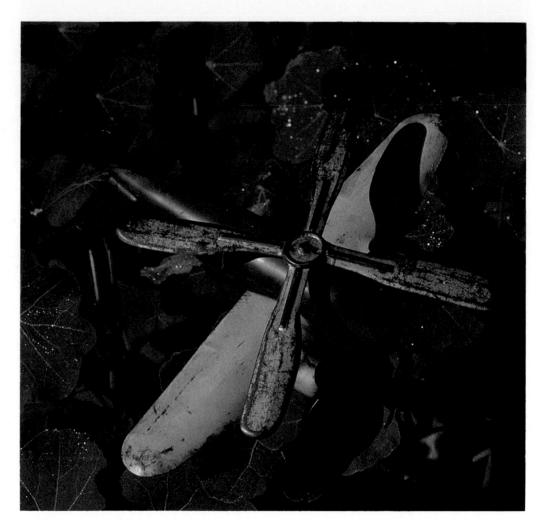

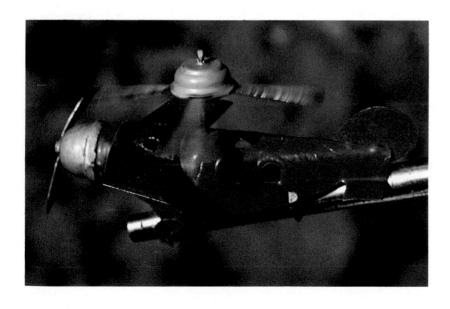

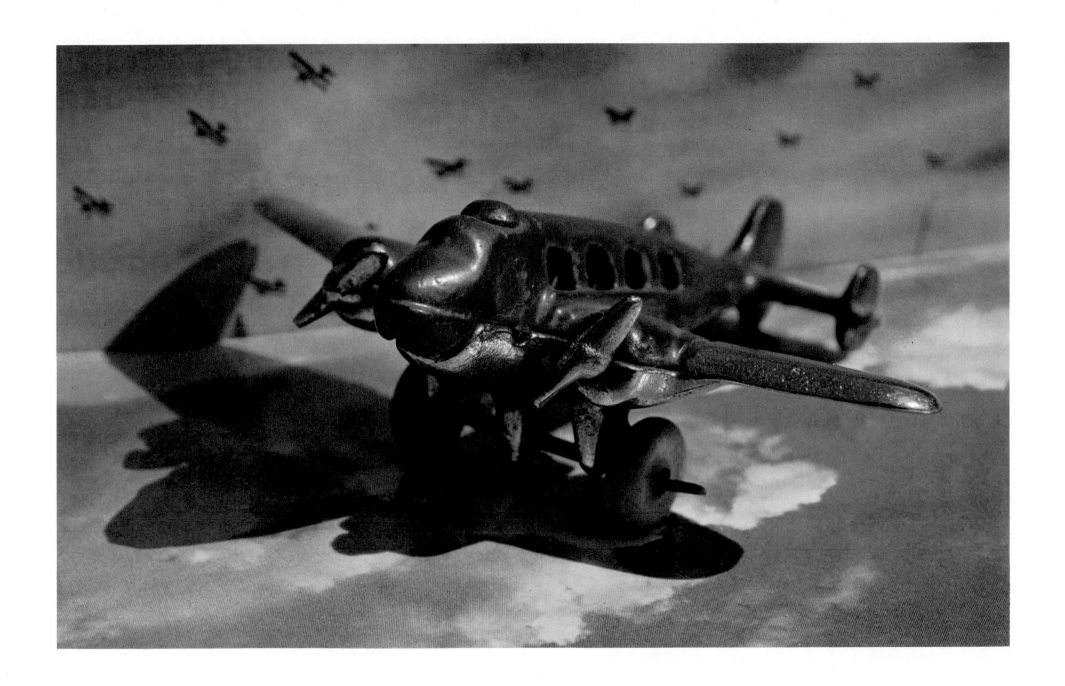

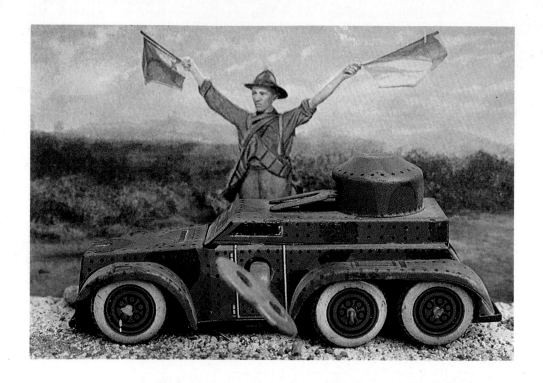

In backyard battlefields tin tanks
spark and clank around cardboard encampments,
clearing the way for penny postcard commandos.

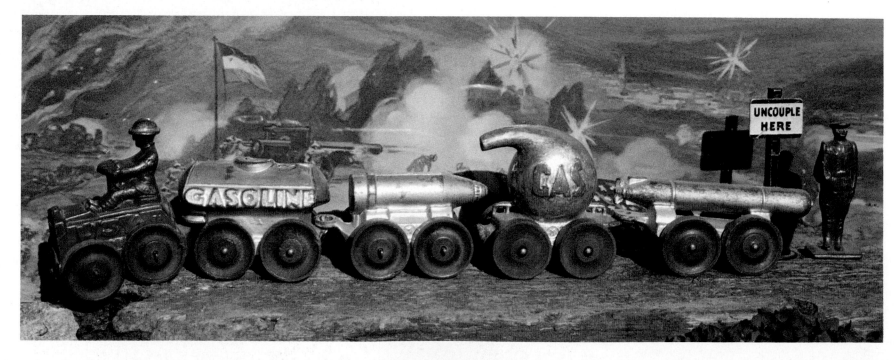

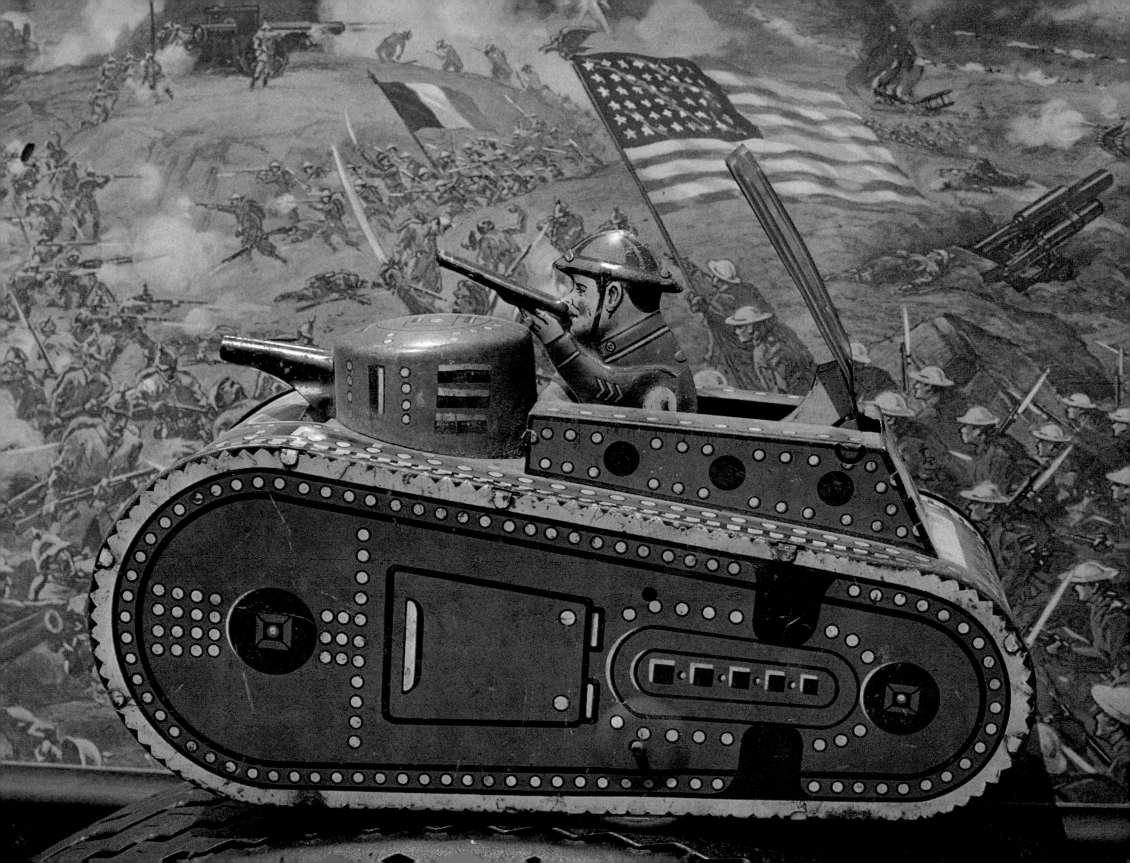

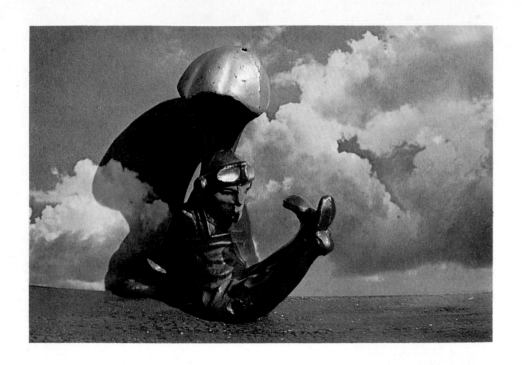

Lead soldiers make up the main forces
on a make-believe battlefield—
camouflaged dimestore doughboys
slog through khaki-colored chaos
charging on with the marching band
and their Uncle Sam to a rhinestone-studded
Stars and Stripes Forever.

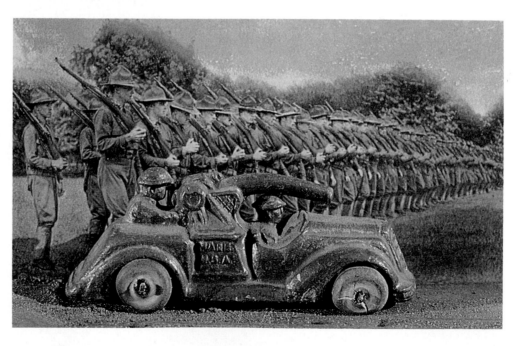

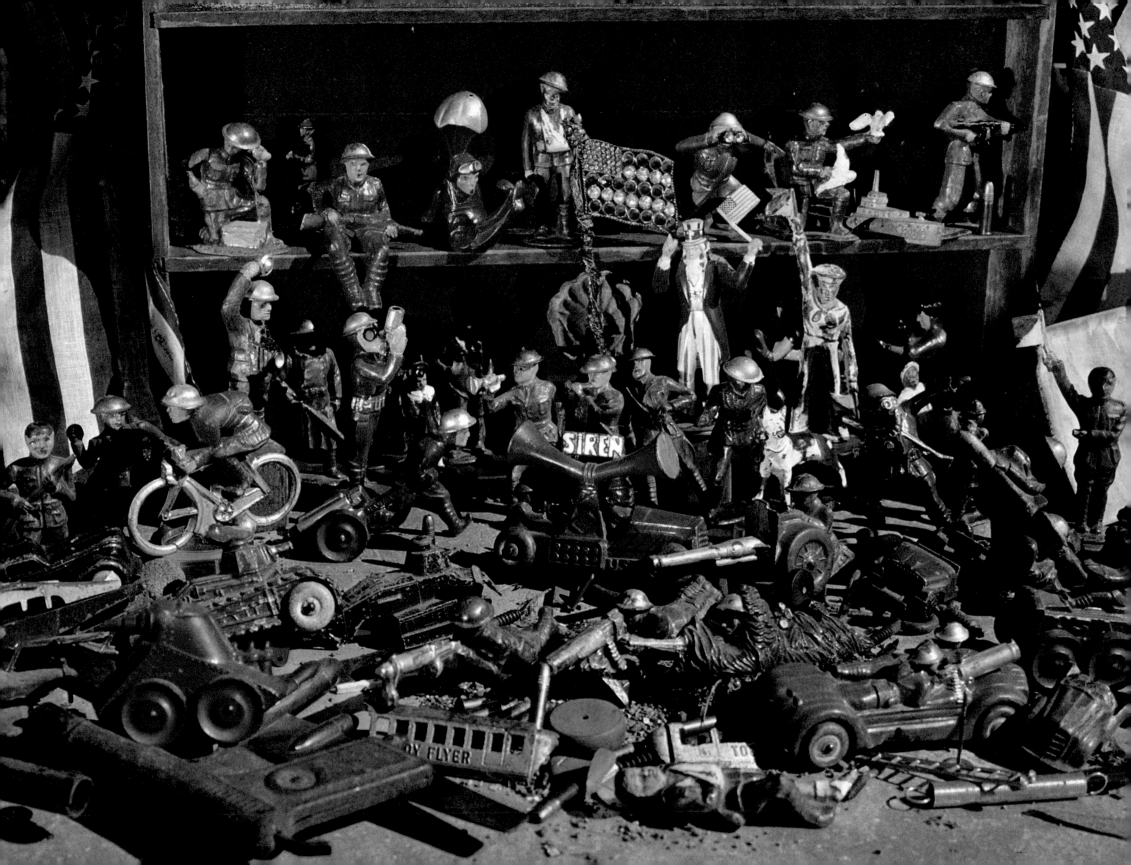

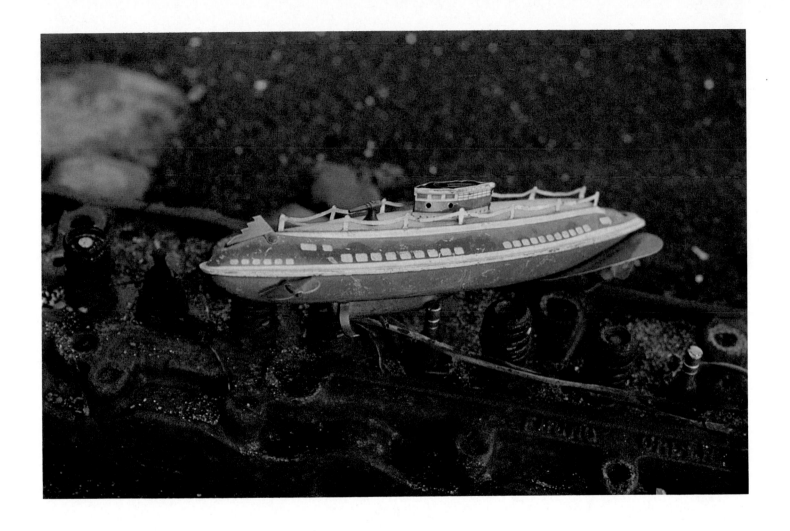

A-a-a-a-ah-o-o-o-gah.
A-a-a-a-ah-o-o-o-gah.
"Take 'er down!"
This spring-motorized metal submarine
can swish and swoosh, dive through the water
and rise on special blue fins and rudder—
and cradle on the rusty bottom.

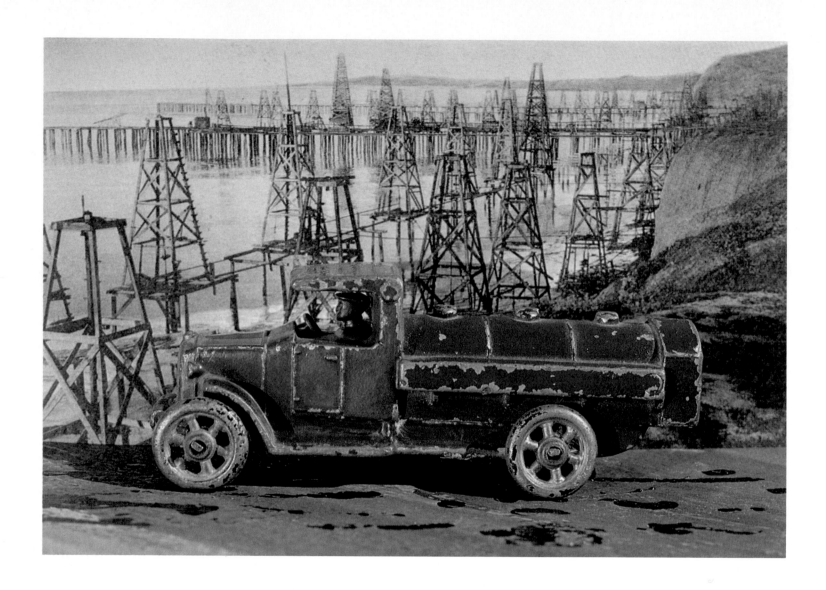

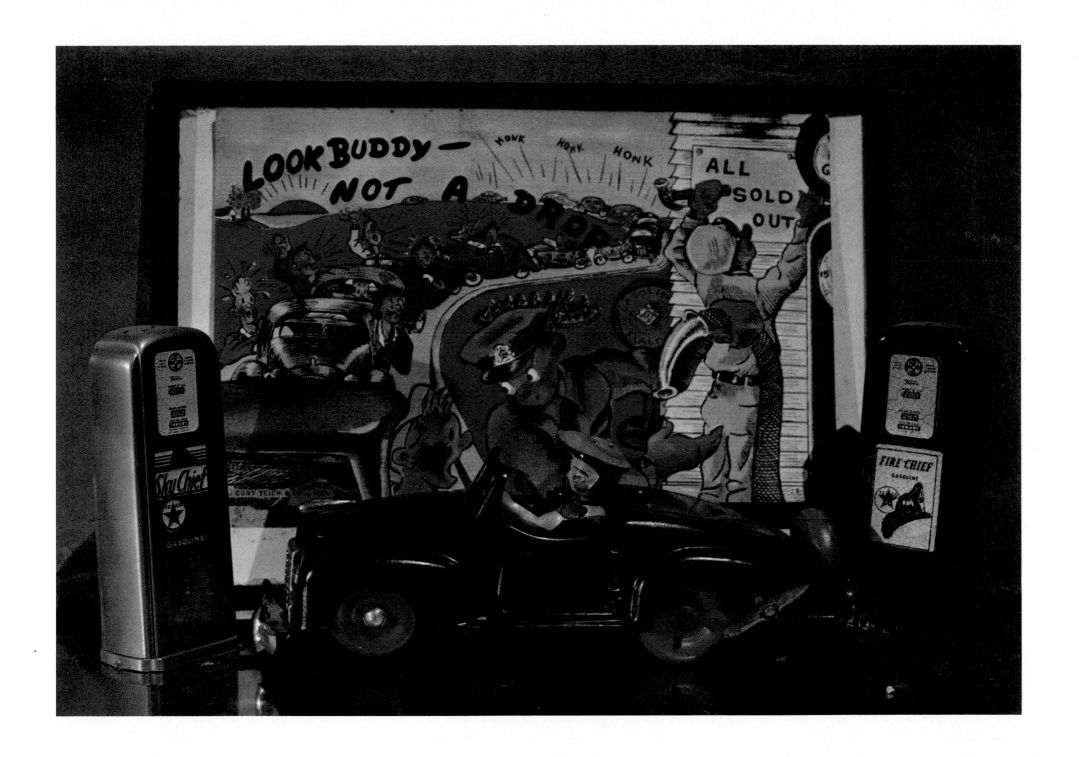

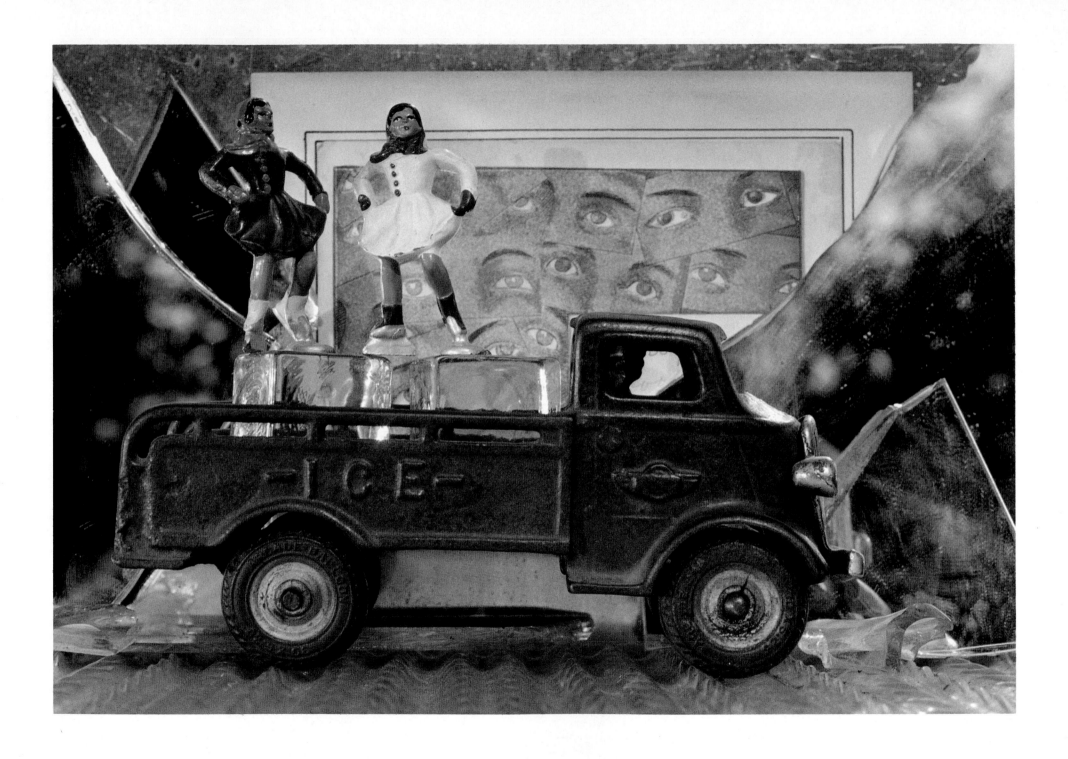

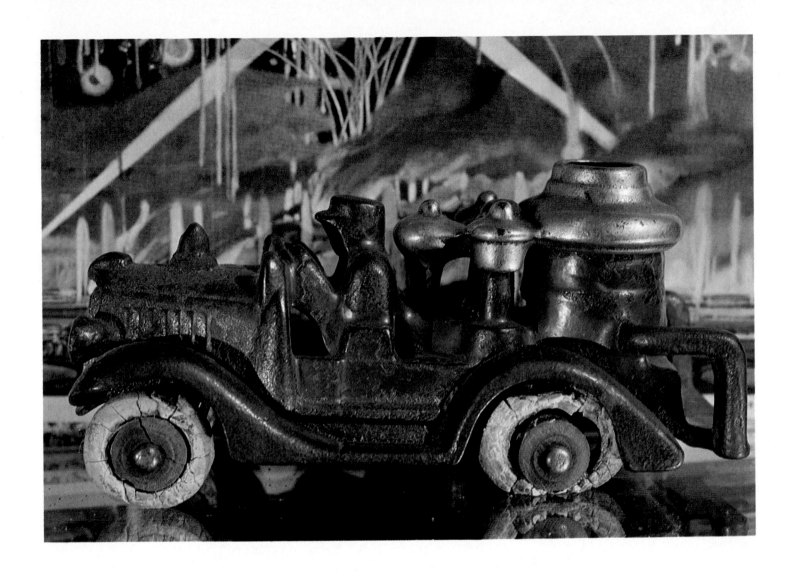

E-e-e-e-e-e-e-e-e-e-e-e!
Coming upon this fiery exploding postcard spectacle
a worn Hubley cast-iron firetruck with its rusty
nickel-plated boiler speeds in on its crumbly old
rubber-donut, red-wooden-hubbed wheels . . .
just in time for the next apocalyptic scene.

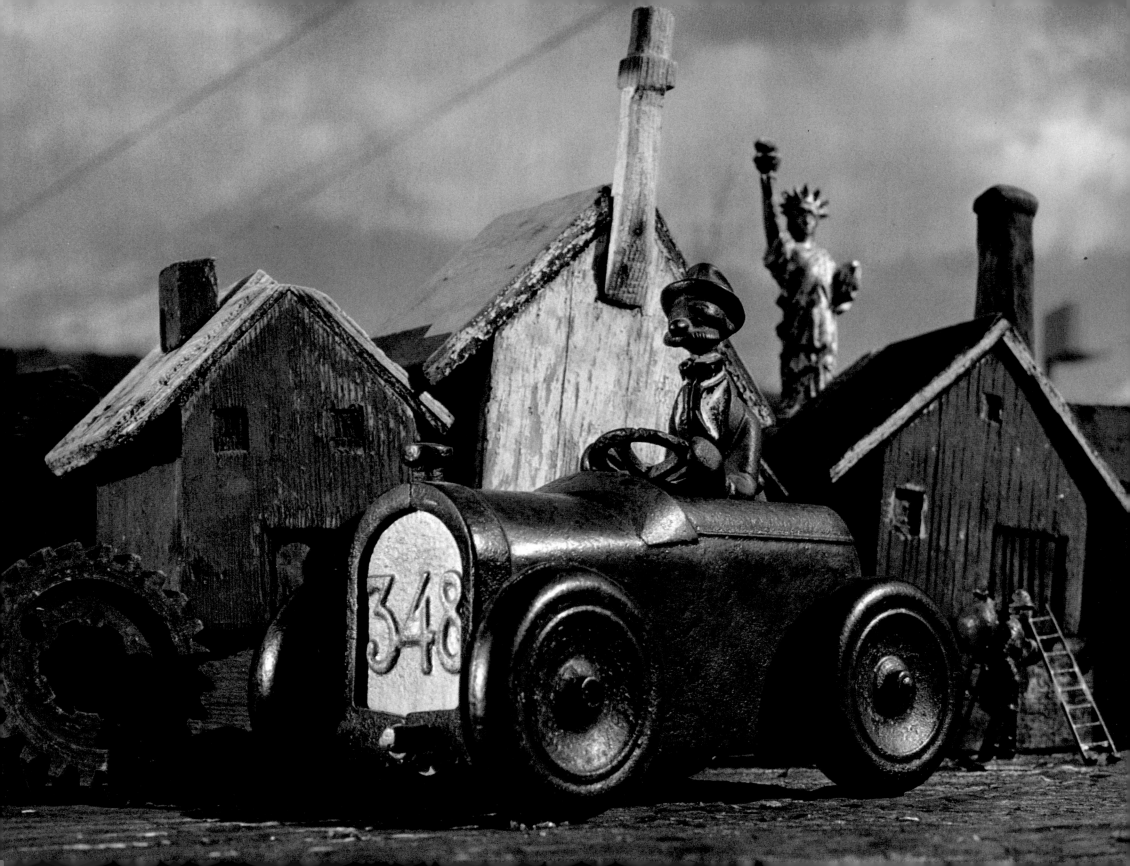

"The Gumps" was a comic strip that featured this fellow,
Andy Gump, who rattles through town dwarfing his midget car,
with the crypto-numbers "348" shining from the radiator.
Andy was a "chinless, optimistic failure," a good-hearted loser,
stomping around in the American Dream. When he got himself
hopelessly involved in a predicament he would cry out in
desperation to his wife: "Oh, Min! Oh, Min!"

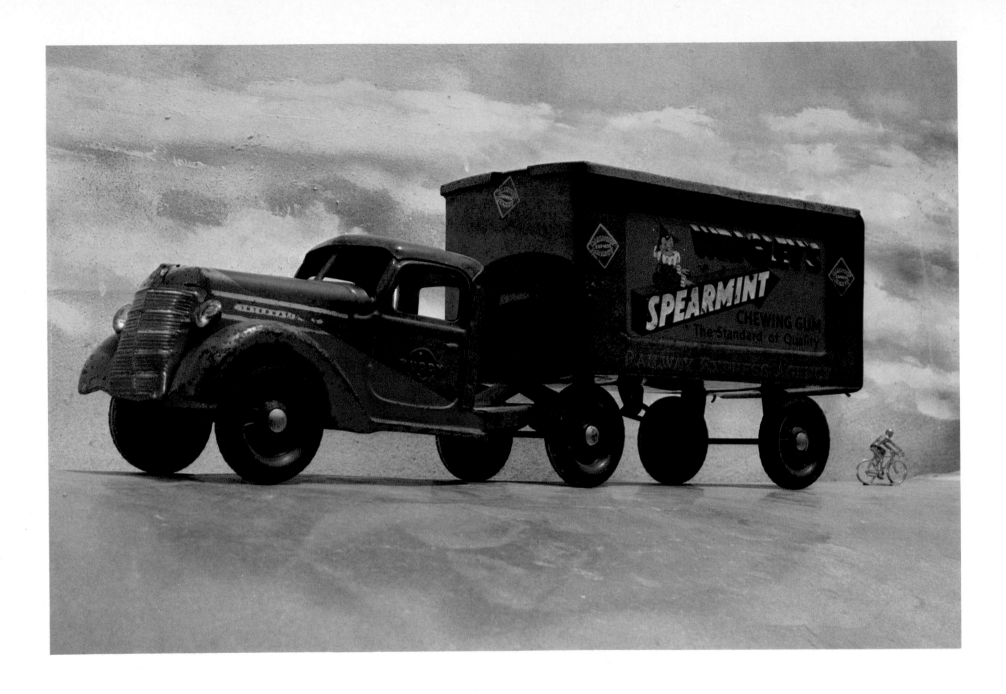

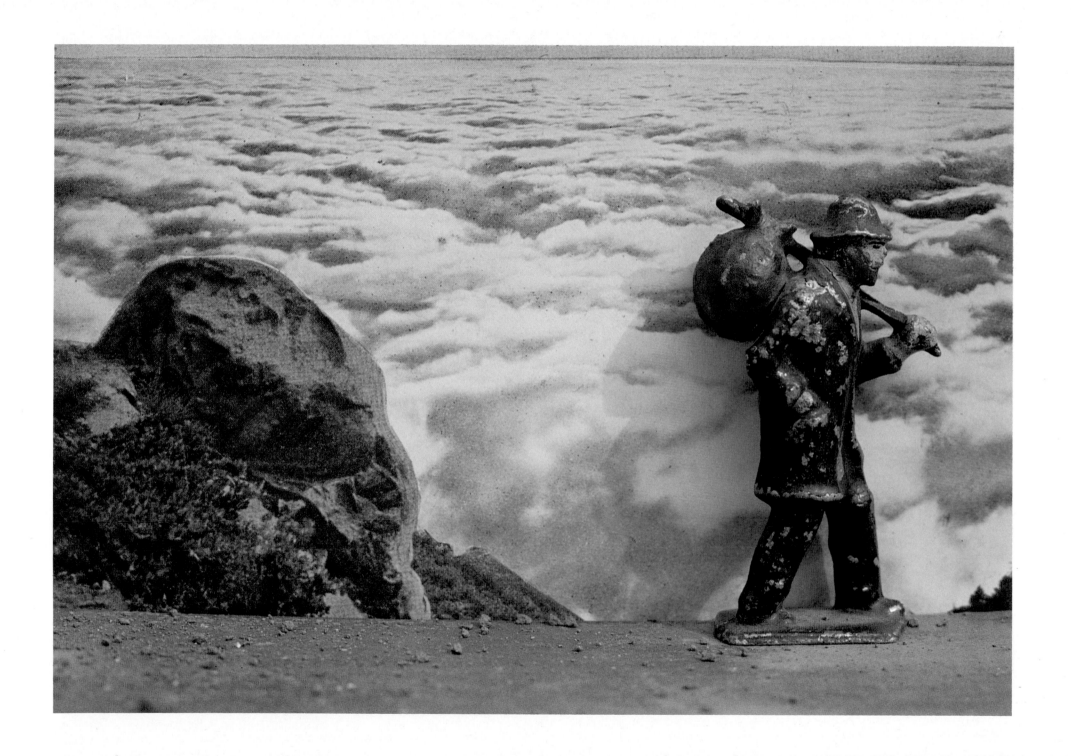

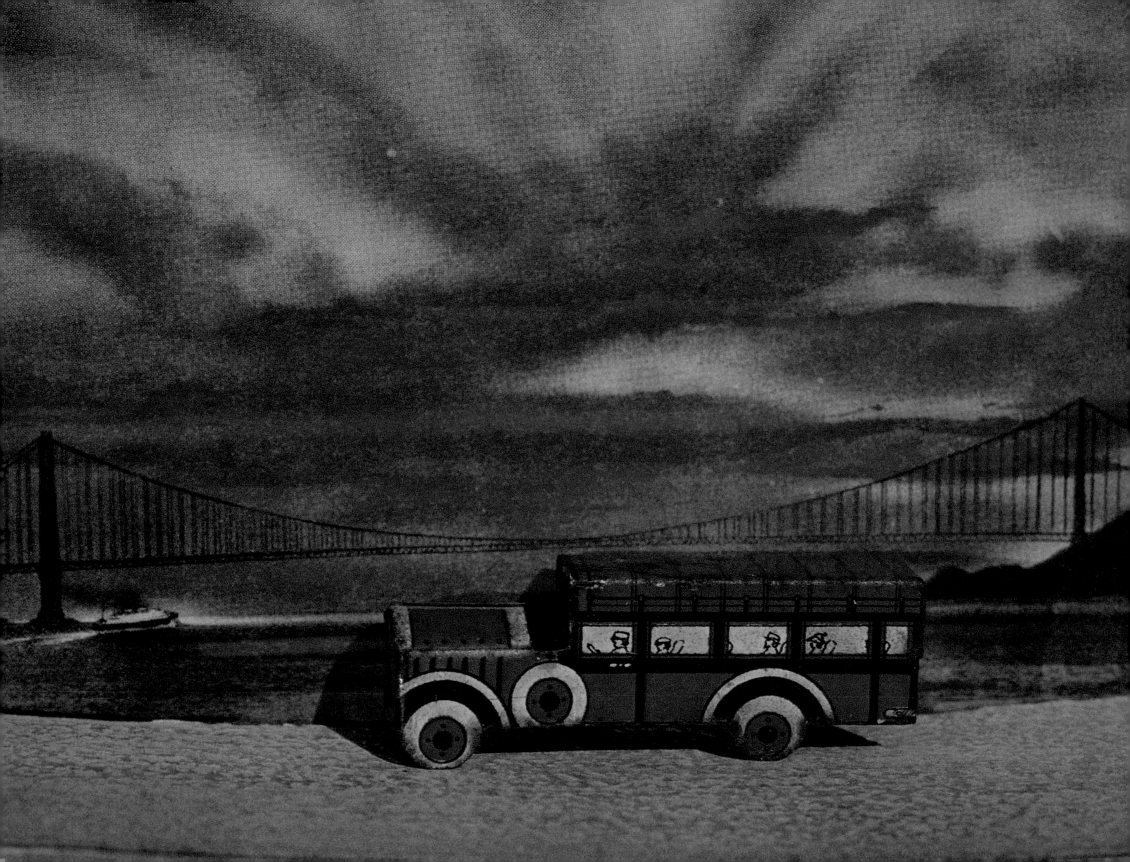

RUBBER TOYS

Rubber toys were cheap and you could find them in the dimestore piled up between thick, green-tinted glass dividers that had the price clipped to them. The toys were formed in molds, had good detail and would *never* rust.

TIN TOYS

The tin toys were made of the same kind of metal as food cans—in fact some of them were actually made of recycled tin. The toys were light to hold, were usually fragile and, like tin cans, they sometimes had sharp edges. The tabs that held them together often snapped off, so the later models had the edges crimped to hold the pieces together. The typical tin toy shows novelty and ingenuity in construction: it often had a clockwork spring mechanism animating it in a variety of movements, so the tin toy seemed to have wit and good humor. The beautiful color and detail were printed on the flat sheets of metal by a lithographic press and the toys were then formed by tools and dies.

STEEL TOYS

Steel toys were constructed from stamped or pressed heavy-gauge automotive sheet metal. They were comparatively large and hefty—the kind of toys you could sit on and not crush. They often used decals for decoration and for commercial messages like those on the Coke trucks.

SLUSH-CAST TOYS

Slush-cast or pot-metal toys were produced by the millions, as plastic toys are today. They differ from other cast-metal toys because they're hollow. After the molten lead-like metal was poured into the mold, the mold was inverted leaving a thin layer of the cooling metal adhering to the surfaces of the mold and producing the hollow casting. Details tended to be softened by this technique. Painted details like the strange expressions on the lead soldiers (and civilians) were done by hand.

PRESSURE DIE-CAST TOYS

Pressure die-cast toys were made by forcing zinc and white-metal alloys into the permanent molds. Sharp, clean details were achieved by this method. These toys were manufactured by machine in huge numbers so a kid could buy one for himself with a nickel or dime out of his own pocket money.

CAST-IRON TOYS

Cast-iron toys were made of molten gray iron poured by hand into sandcasting molds. They were usually cast in halves and were then bolted or riveted together. Some designs incorporated complex interlocking nickel-plated parts such as grilles, chassis, bumpers, and people. The paint was baked on and fine details such as pin-striping were hand-painted or stenciled on later. Cast-iron toys had a unique solid feeling in your hand because of their heavy weight and durable construction. They were also expensive.

APPENDIX

Roadster, p. 1
Cast-iron, 4¼″
Hubley, ca. 1934

Silver Arrow, p. 2
Cast-iron, 7″
Arcade, ca. 1933

Man with Cane, p. 6
Slush-cast, 2¾″
Unknown, 1930s

Racer, p. 8
Tin, 2½″
Unknown, ca. 1935

Tractor, p. 9
Tin wind-up, 11½″
Marx, ca. 1940

Cow, Man with Pump,
Woman with Watering Can,
p. 10
Slush-cast, 2¼″
Manoil, ca. 1935

International Harvester,
p. 11
Cast-iron, 10″
Arcade, ca. 1929

Milk Truck, p. 12
Pressed steel, 10″
Marx, ca. 1940

Stake Truck, p. 13
Cast-iron, 7″
Hubley, ca. 1936

3 Cowboys, p. 14
Plastic, 3″
Unknown, ca. 1945

Lone Ranger, p. 15
Tin wind-up, 8″
Marx, ca. 1940

Dogpatch Band, p. 17
Tin wind-up, 8½″
Unique Art, ca. 1945

Chrysler Airflow,
p. 18, top
Cast-iron, 4″
Arcade, ca. 1935

Austin Truck, p. 18
Cast-iron, 3¾″
Arcade, ca. 1933

Lady, p. 19
Plastic, 2″
Unknown, ca. 1947

Town Car, p. 20
Die-Cast, 4″
Tootsie Toy, 1930s

Sedan, p. 21
Die-cast, 4″
Tootsie Toy, 1930s

Pickle Truck, p. 22
Steel, 12″
Metalcraft, ca. 1935

Buick, p. 23
Tin, 5″
Japan, ca. 1947

Plymouth Sedan, p. 24
Rubber, 4¼″
Auburn, ca. 1940

Ford Sedan, p. 25
Die-cast, 3″
Tootsie Toy, ca. 1935

Ambulance, p. 26
Cast-iron, 4″
Arcade, ca. 1935

Bus, p. 26
Rubber, 4¼″
Sun Rubber, ca. 1940

Friction Car, p. 27
Tin, 4″
Japan, ca. 1950

Greyhound Bus, p. 27
Cast-iron, 8¾″
Arcade, ca. 1938

Auto with Trailer, p. 29
Steel, 25½″
Wyandotte, ca. 1937

Austin Coupe, p. 30
Cast-iron, 3¾″
Arcade, ca. 1933

Black & Red Sedans, p. 31
Die-cast, 2¾″
Tootsie Toy, ca. 1930

Mack Dump Truck, p. 32
Cast-iron, 13″
Arcade, 1930s

Mack Tow Truck, p. 33
Cast-iron, 9″
Champion, 1930s

Cement Mixer, p. 34
Cast-iron, 6½″
Kenton, ca. 1930

Steam Shovel, p. 35
Steel, 12″
Marx, ca. 1940

Dump Truck, p. 36
Slush-cast, 4″
Kansas City Toy, ca. 1938

Dump Truck, p. 37
Cast-iron, 4½″
Arcade, 1930s

Taxi, p. 38
Steel, 9½″
Marx, ca. 1940

Plymouth Coupe, p. 39
Cast-iron, 4½″
Arcade, ca. 1933

Terraplane, p. 40
Cast-iron, 5½″
Hubley, ca. 1935

Model-T Ford, p. 41
Cast-iron, 6¼″
Arcade, ca. 1927

Taxi, p. 42
Cast-iron, 7½″
Hubley, ca. 1930

Yellow Cab, p. 43
Cast-iron, 7″
Hubley, ca. 1940

Charlie McCarthy, p. 45
Tin wind-up, 8″
Marx, 1938

Sedan, p. 46
Die-cast, 5⅛″
Hubley, 1936

Coupe, p. 47
Tin wind-up, 16″
Marx, ca. 1938

Coupe, p. 48
Cast-iron, 6″
Manoil, 1940

Cabriolet, p. 49, top
Die-cast, 4″
Manoil, ca. 1939

Coupe, p. 49
Die-cast, 4″
Manoil, ca. 1945

Racer, p. 50
Tin wind-up, 8″
Marx, 1920s-1930s

Model-A Ford, p. 51
Cast-iron, 6¾″
Arcade, ca. 1930

Car & Motorcycle, p. 52
Cast-iron, 9″
Hubley, 1936

Motorcycle with Sidecar, p. 53
Cast-iron, 5¼″
Champion, ca. 1933

Dick Tracy Squad Car,
p. 55
Tin wind-up, 11″
Marx, 1949

Stutz, p. 56
Tin wind-up, 9½″
Germany, 1946

Coca-Cola Truck, p. 57
Steel, 20″
Marx, ca. 1947

Blue Racer, p. 58
Cast-iron, 7¼″
Hubley, ca. 1936

Orange Racer, p. 58
Cast-iron, 6¾″
Hubley, 1930s

Dodgem Car, p. 59
Tin wind-up, 9″
Unknown, ca. 1935

Chrysler Airflow, p. 60
Cast-iron, 6¼″
Hubley, ca. 1935

Sedan & Coupe, p. 61
Plastic, 4″
Lapin, ca. 1940

Little Girls, p. 62
Slush-cast, 2″
Unknown, ca. 1935

Girl in Rocking Chair,
p. 63
Slush-cast, 1½″
Unknown, ca. 1935

Fire Chief's Car, p. 64
Tin wind-up, 7″
Marx, 1949

Auto, p. 65
Tin wind-up, 6½″
Marx, 1949

Superman, p. 66
Plastic, 6″
Multiple, ca. 1949

Donald Duck, p. 67
Tin wind-up, 4″
Japan, ca. 1949

Truck & Trailer, p. 68
Rubber, 5″
Sun Rubber, ca. 1940

Zeppelin, p. 69
Cast-iron, 5″
Dent Hardware, ca. 1930

Buck Roger's Spaceship, p. 71
Tin wind-up, 12″
Marx, 1934

Battlecruiser, p. 72, left
Die-cast, 4¾″
Tootsie Toy, ca. 1935

Flash-Blast Attack Ship,
p. 62, right
Die-cast, 4½″
Tootsie Toy, ca. 1935

Spaceship, p. 72, bottom
Steel, 6¼″
Wyandotte, ca. 1935

Spaceships, p. 73
Die-cast, 1″
Game markers, ca. 1940

World War II Planes, p. 74
Plastic, 2″
Unknown, ca. 1945

Flying Fortress, p. 75
Tin wind-up, 18″
Marx, ca. 1940

Gyro Plane, p. 76, top
Steel, 5½″
Marx, ca. 1940

Gyro Plane, p. 76, bottom
Tin whistle, 5½″
French, ca. 1940

Airplane, p. 77
Cast-iron, 3″
Arcade, 1940s

Armored Car, p. 78
Tin wind-up, 4″
Japan, ca. 1949

Tractor, Gas Cart, Torpedo,
Gas Car, Bomb, p. 78
Slush-cast, 2¼″
Manoil, 1930s

Pop-up Tank, p. 79
Tin wind-up, 10″
Marx, 1930s

Paratrooper, p. 80
Slush-cast, 3½″
Barclay, 1930s

Cannon Truck, p. 80
Slush-cast, 3½″
Barclay, 1930s

Lead soldiers, p. 81
Slush-cast, 3½″
Manoil/Barclay, 1930s

Battleship "Maine," p. 82
Cast-iron bank, 4½″
Unknown, 1920s

Submarine, p. 83
Steel wind-up, 13″
Wolverine, 1940s

Oil Truck, p. 84
Slush-cast, 3½″
Unknown, 1930s

Lady in Convertible, p. 85
Tin wind-up, 4½″
Japan, ca. 1949

Ice Truck, p. 86
Cast-iron, 6″
Arcade, ca. 1938

Firetruck, p. 87
Cast-iron, 4″
Hubley, ca. 1935

Andy Gump, p. 88
Cast-iron, 7″
Arcade, 1920s

Wrigley's Truck, p. 90
Steel, 24″
Buddy-L, ca. 1940

Hobo, p. 91
Slush-cast, 2½″
Unknown, 1930s

Bus, p. 92
Tin, 1¾″
Unknown, 1930s

Past Joys was printed by Mastercraft Press,
San Francisco, on Warren's Flokote. The
separations were furnished by Color Tech.
The typography was set in Caslon by
Mackenzie-Harris, San Francisco.
The book was edited by Jane Vandenburgh,
and designed by Ken Botto, R. C. Schuettge and
Robert Harriman. Cardoza-James Binding Company
bound both the paper edition and the limited edition
of three hundred slip-cased copies, each numbered
and signed by the author.

A Note on Technique:
All the photography in this book was done without the use
of photomontage or darkroom trickery. Some of the old
postcards used as backgrounds for the toys did rely upon
trick-photo devices and retouching for their special effects.
All the photographs were shot in natural sunlight using
a Nikkormat camera with a micro Nikkor-P Auto 1:35
F-55mm lens. K.B.